IMAGES
of Rail

TROLLEYS OF THE
CAPITAL DISTRICT

On the cover: The hustle and bustle of downtown Schenectady during rush hour is seen in the 1920s. (Pat Nestle, Frank Dodge collection.)

IMAGES
of Rail

TROLLEYS OF THE CAPITAL DISTRICT

Gino DiCarlo

ARCADIA
PUBLISHING

Published by Arcadia Publishing
Charleston SC, Chicago IL, Portsmouth NH, San Francisco CA

Printed in the United States of America

Library of Congress Catalog Card Number: 2008932690

For all general information contact Arcadia Publishing at:
Telephone 843-853-2070
Fax 843-853-0044
E-mail sales@arcadiapublishing.com
For customer service and orders:
Toll-Free 1-888-313-2665

Visit us on the Internet at www.arcadiapublishing.com

This book is dedicated to the four greatest people in the world: my wife Kelly Ann Casadonte DiCarlo, my sons Brady John and Jared Thomas DiCarlo, and my daughter Gianna Kathryn DiCarlo.

CONTENTS

ACKNOWLEDGMENTS

First and foremost, I would like to thank Kenneth Bradford, keeper of his grandfather Joseph A. Smith's railroad collection. Thanks also to the following: Dr. Len Garver for trusting his great trolley collection to me; Pat Nestle, wife and illustrator for famous railroad author the late David F. Nestle, for sharing his photograph collection; the Fred B. Abele Transportation History Collection, New York State Library Manuscripts and Special Collections, Albany, Marty Pickands, curator; Kevin Franklin, historian's office, Town of Colonie; Bill Mischler for digitizing photographs; Don Rittner, Schenectady county and city historian, Efner Research Center, and fellow Arcadia author; and Victoria Garlanda and Teri Blasko from the Saratoga Springs Public Library Saratoga Room. A special thanks goes to my father, the late Domenico DiCarlo, who told me to "stay off those darn railroad tracks," and my parents Anthony and Diana Javarone for always going out of their way to drive by the rail yard.

INTRODUCTION

When it came to first-class transportation, not many cities of the 19th and 20th centuries could do better than the trolley lines of New York's Capital District. From their humble beginnings as horse railroads forming belts around Albany, Schenectady, and Troy, these trolley lines helped move people around Upstate New York until their final exit after World War II.

Governors and lawmakers from all over the state of New York used the United Traction Company (UTC) to hustle around the capital city. There was nowhere in town that they could not reach: Cohoes to the north, Rensselaer to the east, and Mid-Towne Park, a summer getaway outside the city, a popular destination. A baseball stadium in Menands was home to the Albany Senators, and trolley specials ran baseball fans to exhibition games against the New York Yankees. Babe Ruth and Lou Gerhrig were seen by travelers of the UTC. Spectacular bridges brought people across both sides of the Hudson River and even a quaint horse railroad line shuttled employees around Albany's lumber district until 1921.

A connection with the Electric City of Schenectady made it possible for lawmakers to work in the daytime at the capitol and rub elbows with the giant minds of the General Electric Company (GE) in the afternoon. The Schenectady Railway Company prospered through the creations of Thomas Alvah Edison and Charles Steinmetz. Henry Ford is said to have taken a Schenectady Railway trolley to the GE works so he could see them bring good things to life.

The rich and other well to do could catch a trolley car in the Collar City of Troy and be in the racing capital of the world at Saratoga Springs for a 1:00 p.m. post time. A luxury resort at beautiful Lake George was reached by the very trolley line that created it—the Hudson Valley Railway. The line began in Troy with connections to Albany and Schenectady. It also built an amusement park and dance hall at Saratoga Lake, Kaydeross Park, and brought people from all over the state to the famous mineral springs of the Saratoga Spa State Park.

A connection with the Schenectady Railway at Glenville would get one aboard the Fonda Johnstown and Gloversville Railroad. Special nonstop trips were run from Albany to Gloversville and north via trolley, then steam locomotive to "the Gem Resort of the Adirondacks," Sacandaga Park. Harry Houdini, W. C. Fields, and Al Jolson were just some of the talent that made regular appearances at the park.

The Ballston Terminal Railroad was a short line that connected the village of Ballston Spa with both the Schenectady and Hudson Valley Railways. The inventor of the paper bag, George West, had a private trolley stop to whisk him to his paper bag factory in Ballston from his palatial mansion in Rock City Falls.

The Albany and Hudson Railroad stopped right at the edge of the capital city and brought people and supplies along its third-rail line to the city of Hudson 35 miles south. Making stops at its own amusement park in Kinderhook, this became quite the popular destination. Connections could also be made to bring one even farther south to the greatest city in the world—Manhattan.

One

SCHENECTADY RAILWAY COMPANY

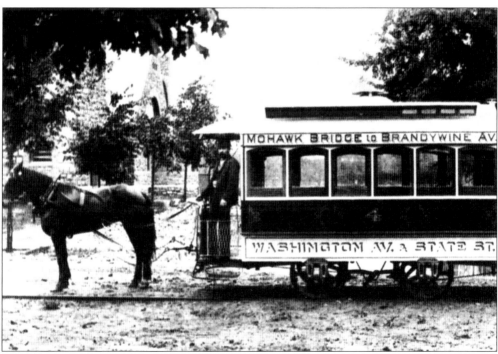

Beginning as a horse railway line after the Civil War, the Schenectady Street Railway Company made its start at the bottom of State Street and ended just above the armory on Nott Terrace. Many trolley lines in the United States started as a merging of local horsecar lines, but the Schenectady Railway remained the same company, from horsepower to electrification. This photograph shows one of the first horsecars in operation on the line, running from Washington Avenue to Brandywine Avenue. (Don Rittner.)

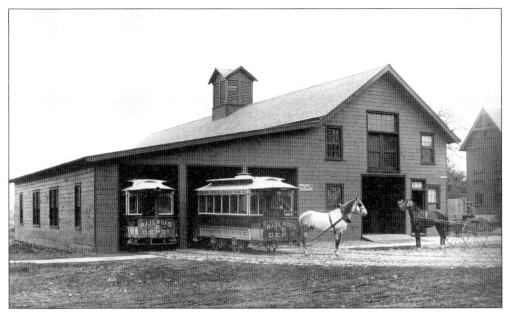

After the extension from State Street Hill to Brandywine Avenue, a barn was constructed between Albany and State Streets to accommodate the rolling stock of the company. This photograph was taken in 1888. (Don Rittner.)

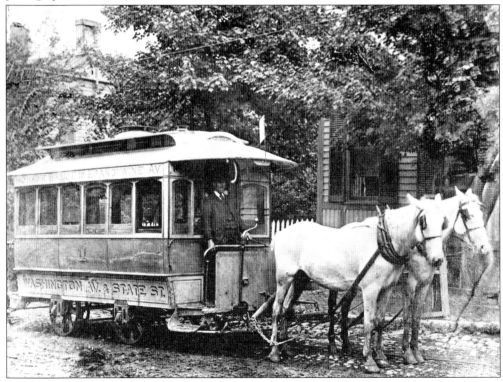

This photograph shows the last horsecar run on the Schenectady Street Railway. The date is July 2, 1891. The trip ran from the Mohawk River bridge at Washington Avenue and ended at Brandywine Avenue. (Don Rittner.)

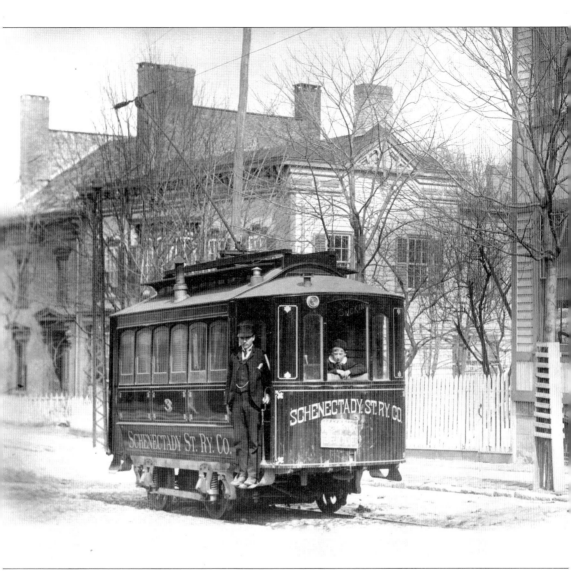

Here is Schenectady Street Railway No. 3 right after the line was electrified in 1892. In the window of the car is little John Vrooman. The conductor's name is not known. The car is in front of the Jacob Vrooman House. The Vroomans were some of the first settlers in Schenectady, and their property was located on North State Street near the current railroad station. (Don Rittner.)

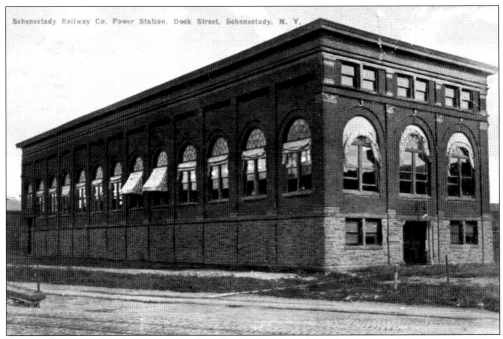

A powerhouse and carbarn were built at Fuller Street and Dock Street in 1899. The buildings were located not far from the General Electric Company (GE) works and the Erie Canal. (Author's collection.)

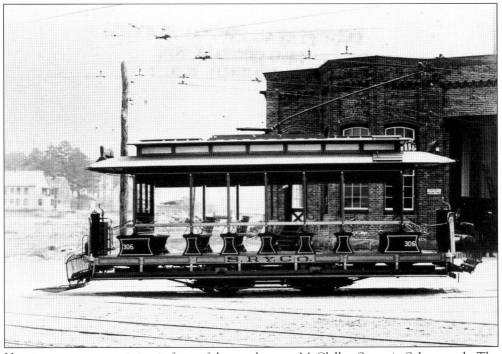

Here is a neat open car sitting in front of the new barn on McClellan Street in Schenectady. The creation of new lines to Albany and Troy deemed it necessary to build a new facility in 1903 to handle the growing number of cars used on the line. (Smith/Bradford collection.)

This is the original downtown Schenectady waiting room for the Schenectady Railway Company. This was 410 State Street, home of Cherry's News Room. In 1913, a new waiting room was built farther up at 512 State Street. Cars could be boarded for trips to Scotia, Goose Hill, Mont Pleasant, Albany, Troy, and the Bellvue area of Schenectady. (Author's collection.)

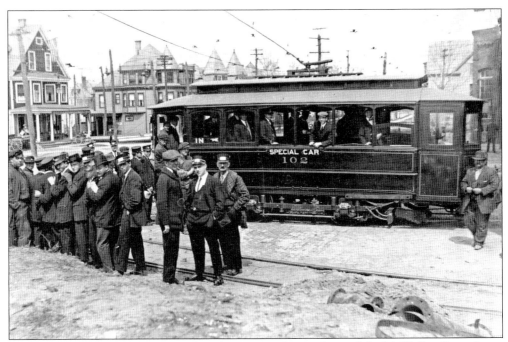

Here is an enthusiastic new group of conductors standing in front of the McClellan Street barn. In the early days of the company, motormen were paid $2 per day. The highest-paid employee in the company was the supervisor/electrician, who pulled in $2,400 per year. (Nestle collection.)

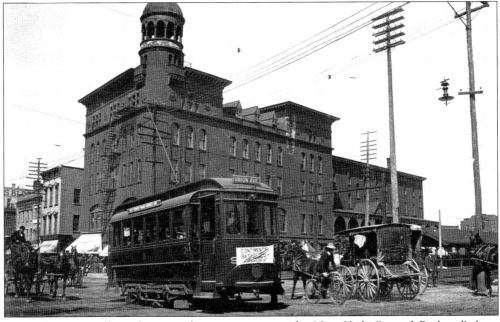

A small "Toonerville"-style car makes its way across the New York Central Railroad's busy four-track Chicago line in downtown Schenectady, just passing the Edison Hotel. This part of State Street was a major transportation hub with the service of the Schenectady Railway, the Erie Canal from Albany to Buffalo, and the ever-busy main line of the New York Central Railroad, which ran nonstop between Chicago and New York City. (Smith/Bradford collection.)

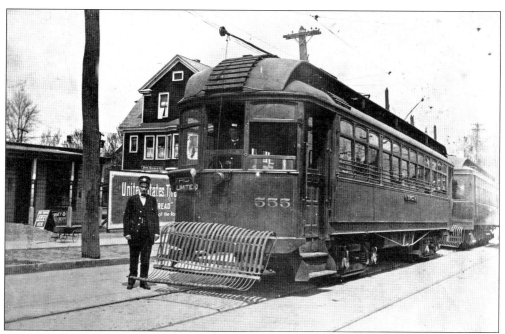

Trolley travel in the Capital District proved to be very popular. A 16-mile line was built to the capital of Albany in September 1901, and then another 16-mile stretch was built to connect the Collar City of Troy and Schenectady in 1902. Here a motorman poses with car No. 555 on Troy-Schenectady Road. (Smith/Bradford collection.)

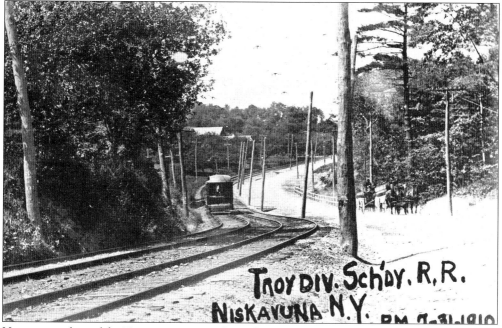

Here is a car bound for Troy, just crossing the Lisha Kill bridge and making its way up the hill in Niskayuna. Troy-Schenectady Road can be seen on the right-hand side of the photograph. This view may be familiar to travelers of present-day Route 7 as one makes one's way from the town of Colonie to the Schenectady city line. (Frank Dodge collection.)

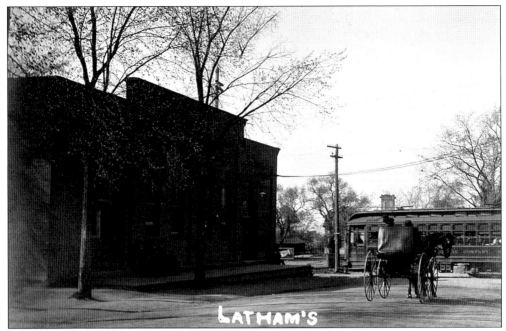

Several substations were needed to power the Schenectady Railway Company. This is the Troy line's substation at Latham's. The 's has been dropped, and this area is currently referred to as Latham. This building remains today behind a gas station on the south side of the Latham traffic circle. (Kevin Franklin, Office of the Historian, Town of Colonie.)

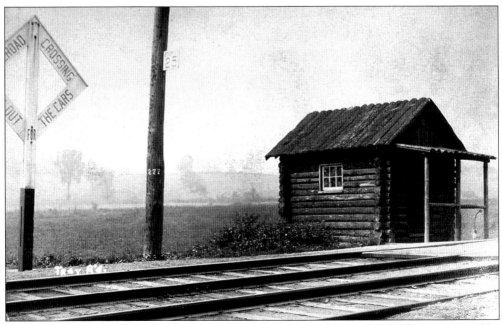

Here is the log cabin station at stop No. 25 on Troy-Schenectady Road. This location would be in the vicinity of Airport Road. (Kevin Franklin, Office of the Historian, Town of Colonie.)

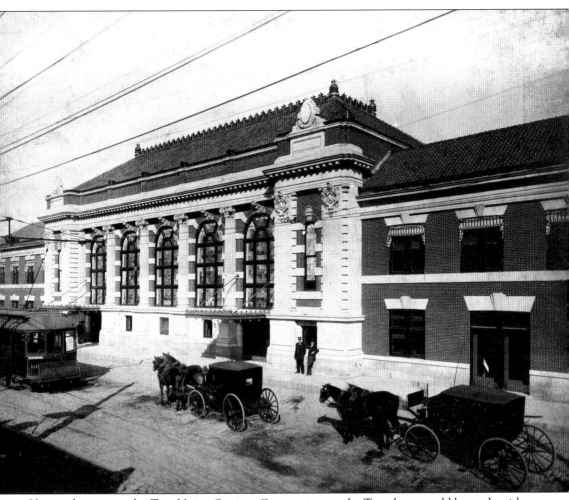

Here is the spectacular Troy Union Station. Connections at the Troy depot could be made with Albany's United Traction system, plus service from the Schenectady Railway Company's parent companies, the Delaware and Hudson and New York Central Railroads, and trips to Boston via the Hoosac Tunnel on the Boston and Maine Railroad. (Smith/Bradford collection.)

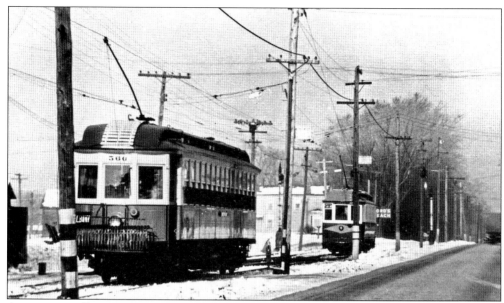

A trip on a trolley car to the city of Albany always proved to be an adventure. This photograph shows cars heading to Albany and Schenectady on what was dubbed "the Speedway." The introduction of the motorcar and a long stretch of straight road paralleling the trolley tracks meant racing was not out of the question. An unpaved highway full of bumps was no challenge to the first-class right-of-way of the Schenectady Railway until asphalt raised the stakes and showed that the automobile was the new king of the road. (Smith/Bradford collection.)

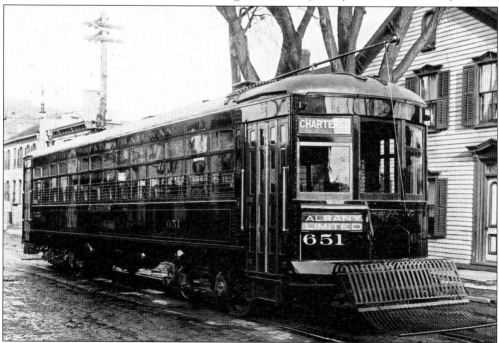

Here is Albany car No. 651 on Church Street in Schenectady on its way to the state capital. Car No. 651 was built by the Cincinnati Car Company in 1916. Cars like this ran 15 minutes apart during the day and always at the top of the hour. (Nestle collection.)

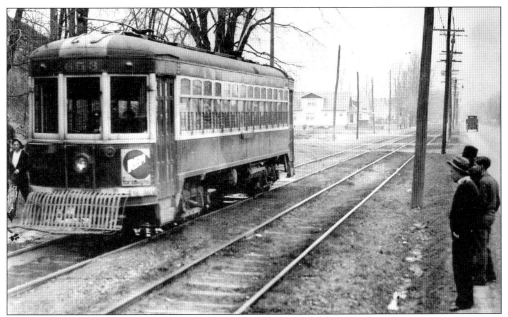

Here is No. 653 making a stop at the Wolf Road crossing in Colonie. Located at about the halfway point between Albany and Schenectady, this area is a busy route for the Schenectady Railway's heir, the Capital District Transportation Authority. The Adirondack Northway now crosses this intersection, and buses drop off shoppers to Colonie Center and Northway Mall. (Smith/Bradford collection.)

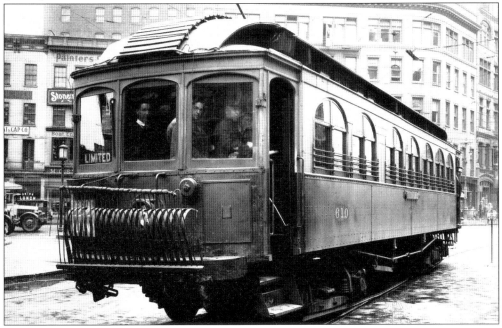

Making its way to the plaza in Albany, No. 610 readies to disembark passengers. The trolley is passing in front of the still-standing Delaware and Hudson Company offices, now the New York State Department of Education. A loop was made, and cars returned to Schenectady from here. (Smith/Bradford collection.)

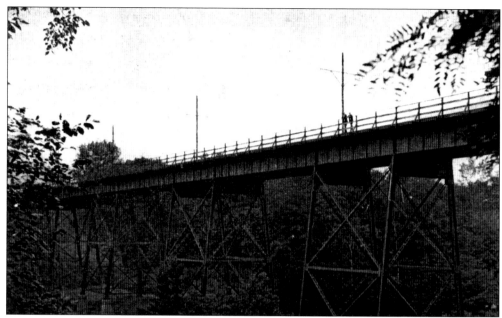

Here is the newly completed Cotton Factory Hollow Bridge in 1905, connecting the city of Schenectady with the then-suburb of Mont Pleasant. Residents of Pleasant Valley complained that a connection with Schenectady proper needed to be made, and a petition to the railroad was answered. Crowds lined up daily to watch the traveler, a moving derrick, hoist the girders into place to complete the bridge. (Author's collection.)

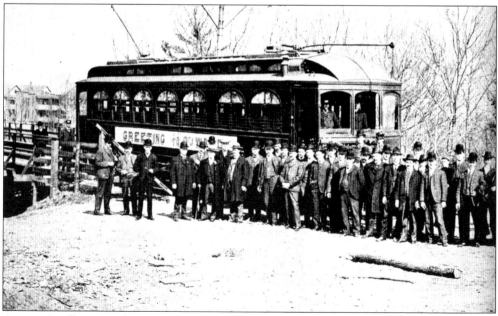

A special trolley carried officials from the city of Schenectady as well as Schenectady Railway officials to the ceremony on the Mont Pleasant side of the bridge on March 31, 1905. This bridge outlived the trolley line and was turned over to the City of Schenectady in 1950 and converted to a highway pedestrian bridge. The bridge remained in service until the early 1990s, when it was replaced by a newer viaduct that now crosses Interstate 890. (Len Garver collection.)

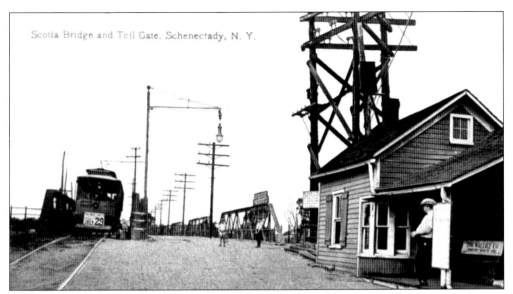

The city of Schenectady was connected with Scotia by trolley via the Washington Avenue bridge, a traffic and railroad bridge located on the Mohawk River. A toll collector stands ready to collect his next fare while a car arrives from Scotia. The Schenectady Railway made a deal with the owners of the bridge providing service far into the village of Scotia in exchange for reduced rates to cross the bridge. The completion of the Western Gateway Bridge on December 16, 1925, made this bridge exclusively a trolley bridge until its condemnation in 1938. This bridge was also used by the Fonda Johnstown and Gloversville Railroad to access the city of Schenectady on its electric division from Gloversville. (Author's collection.)

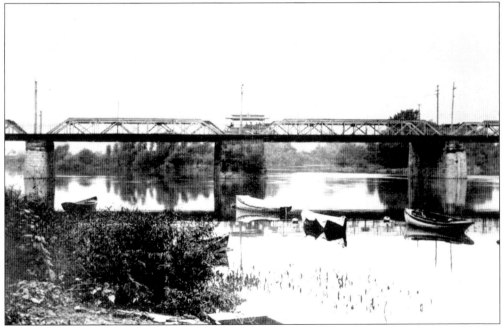

Here an open car of the Schenectady Railway makes its way from Schenectady to Scotia crossing a very serene Mohawk River. An ice jam in the winter of 1938 caused damage to the piers of the bridge, which made it unsafe for crossing. It was eventually demolished in 1939. (Don Rittner.)

In its biggest feat yet, the Schenectady Railway connected the city of Schenectady with Ballston Spa and eventually Saratoga Springs. This photograph shows the grand opening of the line in 1903. Car No. 65 sits in front of the Old Iron Spring in the village of Ballston Spa. (Nestle collection.)

Here is the official opening of the extension to Saratoga Springs in 1907. The photograph was snapped from the roof of the Victorian waiting room of the Hudson Valley Railway, which shared the location with the Schenectady Railway Company. (Frank Dodge collection.)

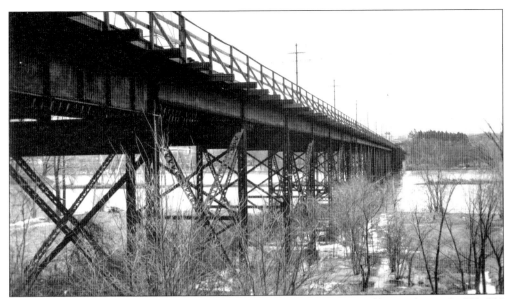

Here is the eighth wonder of the world. Once dubbed the "Longest Trolley Bridge in the World," the 1,800-foot-long aqueduct bridge connected Schenectady with Rexford. Construction started in May 1903 and was completed in the summer of 1904. This bridge spanned the Troy and Schenectady Railroad as well as the Mohawk River and original Erie Canal. (Fred B. Abele collection.)

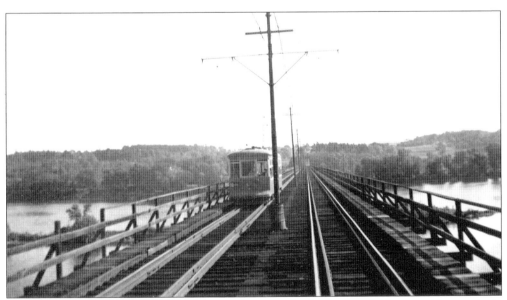

Built to sustain spring floods and ice jams on the river, this bridge lasted 40 years without a single incident. The first car across the bridge was on June 1, 1904, and the last was on December 6, 1941. The bridge was dismantled in 1943 with the bulk of the scrap going to the war effort. (Author's collection.)

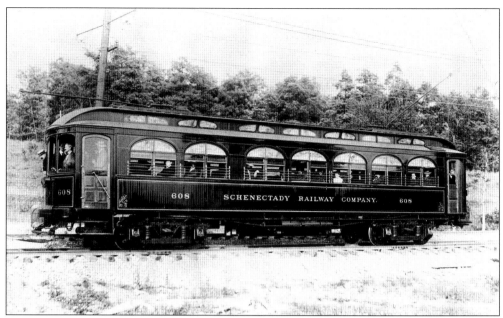

Since GE played a major role in the creation of the Schenectady Railway and its power plants, GE also used the line as testing for various equipment. The Saratoga–Ballston line was a popular avenue to test new designs. No. 608 is seen here south of Ballston Lake making a test run. This stretch of track provided mostly interurban travel and could incorporate high speeds. (Author's collection.)

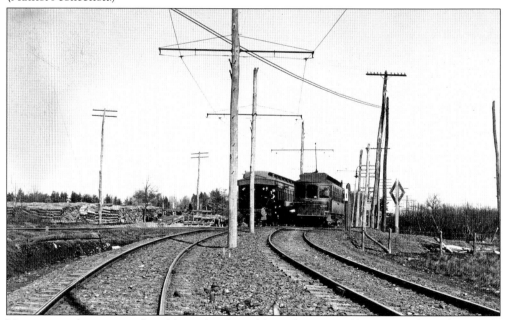

Here is an early meeting of southbound and northbound cars in Ballston Spa. The Schenectady Railway Company parceled the right-of-way of the Delaware and Hudson Railroad (part controller of the line) for most of the trip between Alplaus and Saratoga. Until the official opening of the line to Saratoga, passengers would exit trolleys in Ballston Spa and take a Delaware and Hudson passenger coach the rest of the way. (Author's collection.)

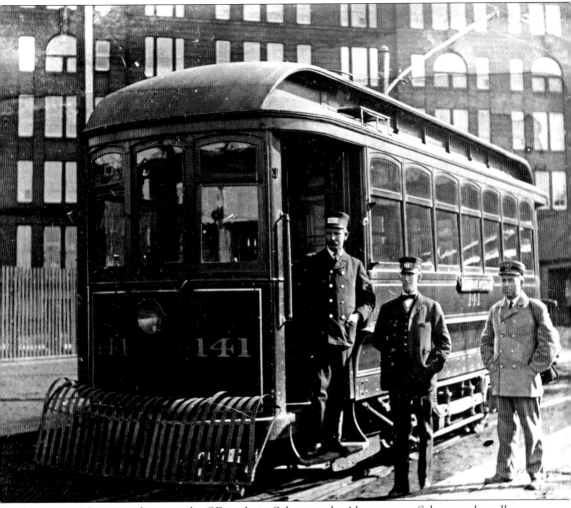

Here is car No. 141 and crew at the GE works in Schenectady. Almost every Schenectady trolley car made a trip around the GE loop, bringing workers from all over the Capital District. The original studio for radio station WGY was located near the GE loop. In the summer months, the windows of the radio station were left open and banging and clanging of trolley cars could be heard all over WGY's broadcast area. In the early days of radio, WGY's signal carried all over the eastern seaboard. It was not out of the question for its signal to carry all the way over to Europe where a listener in Great Britain could catch a Schenectady local news program and the sound of noisy trolley cars working in the background. (Smith/Bradford collection.)

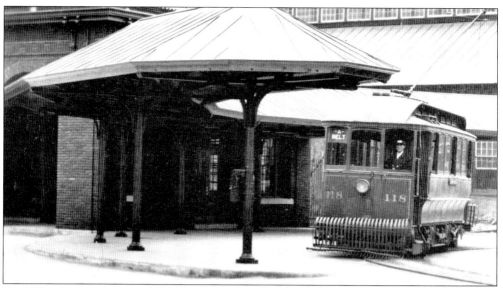

No. 118 makes its way around the actual GE loop in the early 1920s. (Smith/Bradford collection.)

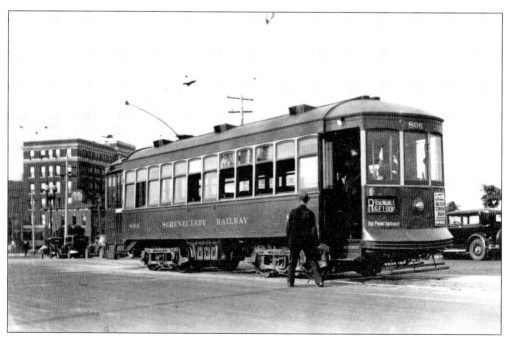

Here is a car leaving the GE works on its way to Rosendale Road. Rosendale Road is located on the border of the city of Schenectady and the Niskayuna town line. It was also one of the stops on the Troy line. (Smith/Bradford collection.)

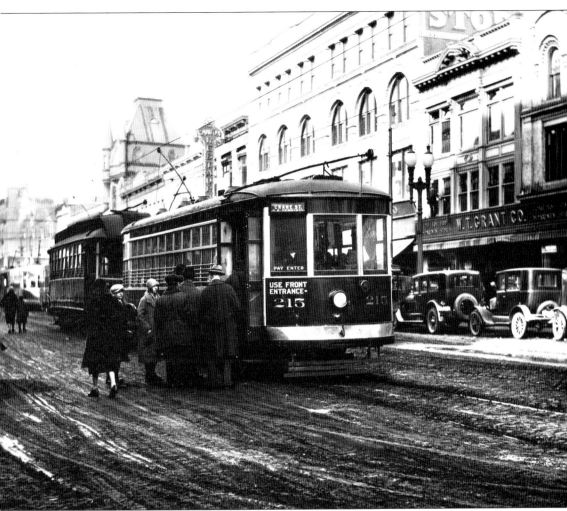

Downtown Schenectady was a booming city 80 years ago. Before the Great Depression, trolleys like this Bellvue car brought people to first-class shopping stores like the Carl Company (to the left, beyond view), top-notch entertainment at Proctor's Vaudeville Theater, and world-class restaurants and four-star hotels like the Hotel Vendome, whose cupola-style rooftop is seen in the background. The city of Schenectady's Metroplex complex has now restored some of the elegance the city once enjoyed with restaurants, a revamped Proctor's Theater, and a multiscreen cinema. (Nestle collection.)

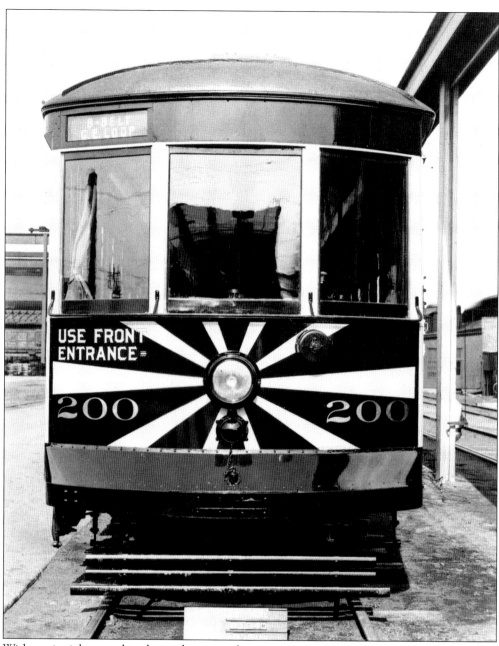

With a paint job created to alert pedestrians of its presence, No. 200 is ready to go in this builder's photograph. The sunburst certainly was eye-catching, but many people thought it resembled the war flag of imperial Japan so it was painted over. (Nestle collection.)

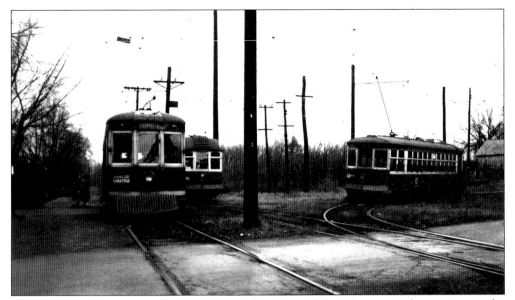

A very busy meeting is seen here at Alplaus Junction. Alplaus Avenue is the crossing in the photograph. The car on the left is coming from Saratoga Springs, the middle car is headed there, and the car on the right is on the Rexford loop heading toward Rexford. (Fred B. Abele collection.)

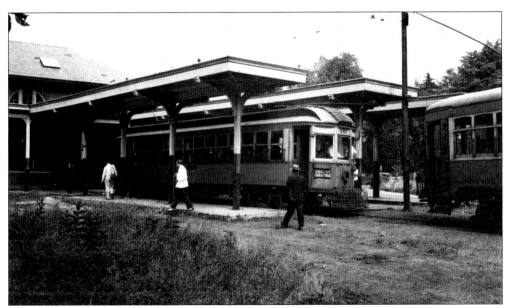

By this time in the late 1930s, the Hudson Valley Railway was no more and the Schenectady Railway was the sole occupant of the Saratoga Springs station. A group of railfans wander around the grounds of the still-standing station. (Saratoga Springs Public Library.)

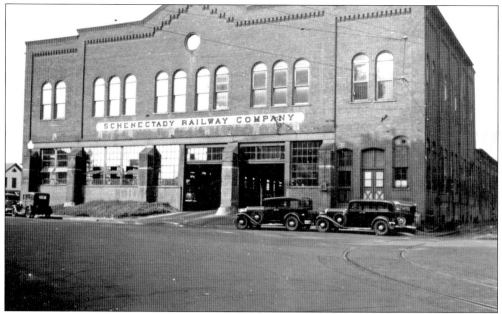

The Fuller barn is seen in a peaceful situation. Although this carbarn was of good size and very busy, the McClellan Street barn was the epicenter of the line. (Nestle collection.)

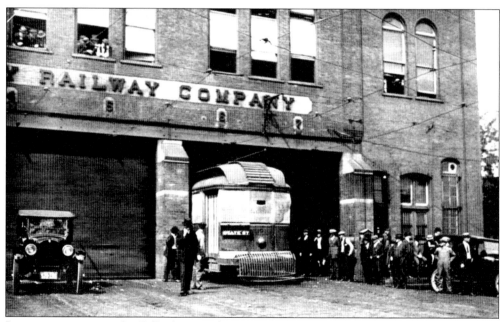

In a tenser situation, the Fuller barn is the scene of a strikebreaker taking a trolley on a run. In the summer of 1923, a huge labor dispute erupted and inconvenienced passengers for several months, while employees campaigned for higher wages. The car here has its windows covered with wire mesh to protect passengers from rock-throwing strikers. (Len Garver collection.)

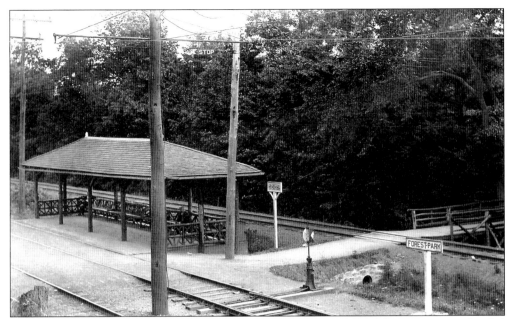

With the closing of the former Brandywine Park, the Schenectady Railway Company decided to build a picnic ground on the shore of Ballston Lake. Called Forest Park, it was built in 1904 as the Ballston line was created. Many excursions were run from Schenectady to the park for swimming, dancing, canoeing, and a merry-go-round. (Author's collection.)

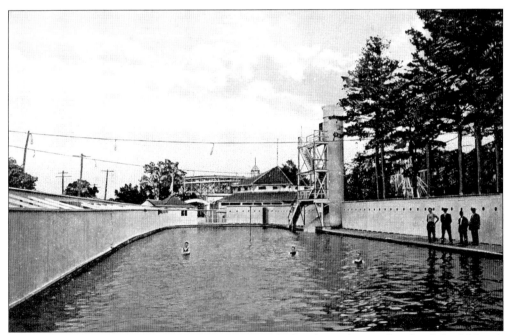

Although not Schenectady Railway property, Rexford Park on the north side of the Mohawk River was a popular destination for Schenectady trolleys. Here is the bathing pool, along with its slide. In the background are the roller coaster and carousel. (Author's collection.)

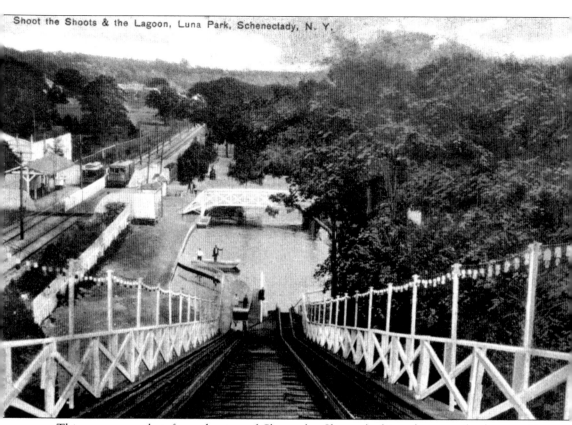

Shoot the Shoots & the Lagoon, Luna Park, Schenectady, N. Y.

This scene was shot from the top of Shoot the Shoots looking down at the lagoon. Two Schenectady Railway Company trolley cars wait at the depot on the left. Rexford Park went by other names. It opened in 1906 as Luna Park and was purchased by Fred Dolle in 1911, and the name was changed to Dolle's Park. The Depression hit the park hard, and it eventually closed in 1933. (Author's collection.)

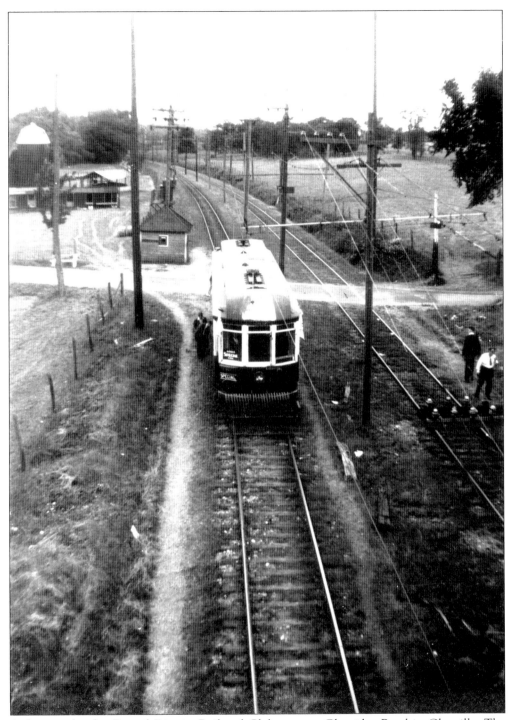

A fan trip for the Capital District Railroad Club stops at Glenridge Road in Glenville. The shelter in the background was set on fire when the Saratoga line closed due to a souvenir hunter knocking over a lit woodstove. (Fred B. Abele collection.)

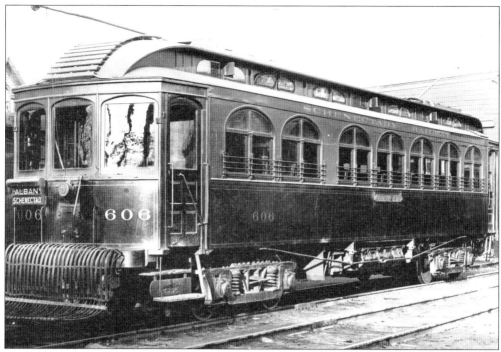

The early 1930s was the time when the Schenectady Railway Company grew smaller in size. First to go was the Albany–Schenectady line on July 28, 1933. No. 606 was one of the last cars to make the run from Schenectady to Albany. (Nestle collection.)

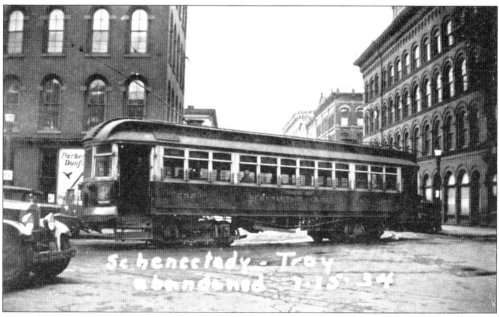

Schenectady - Troy
abandoned 7-15-34

Second to go was the Troy line. Here is No. 555 making its last trip through downtown Troy on July 15, 1934. The W&LE Gurley building is on the right. (Smith/Bradford collection.)

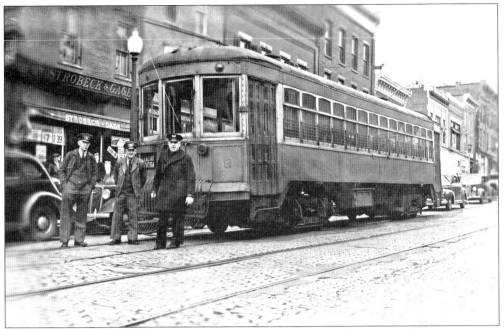

Sunday morning, December 7, was the last day of operation on the Saratoga/Ballston line. No. 650 and its crew are seen here posing with one of Ballston Spa's finest on Milton Avenue in the village. Just a few hours later, America would learn of the sneak attack of imperial Japan on the U.S. naval forces at Pearl Harbor. (Frank Dodge collection.)

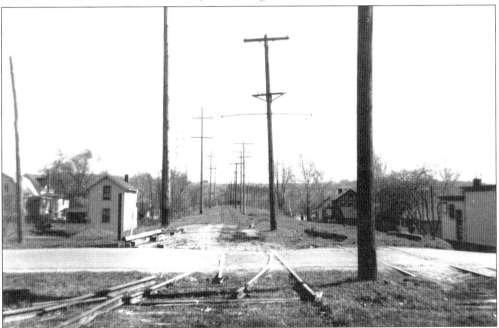

The village of Alplaus takes on a different appearance as the Ballston line of the Schenectady Railway Company is removed from its environs. Looking southward and crossing Alplaus Avenue, the Schenectady Railway Company made its approach to the Mohawk River bridge from here. (Fred B. Abele collection.)

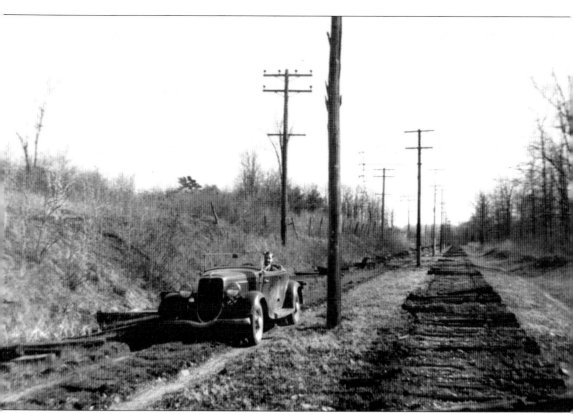

Trying to relive a trip down the Ballston line, Tom Dempsey takes his convertible for a ride along the old right-of-way on April 4, 1942, just a few months after the line was abandoned. This view looks south toward Alplaus Junction and is on present-day Bruce Drive in Glenville. (Fred B. Abele collection.)

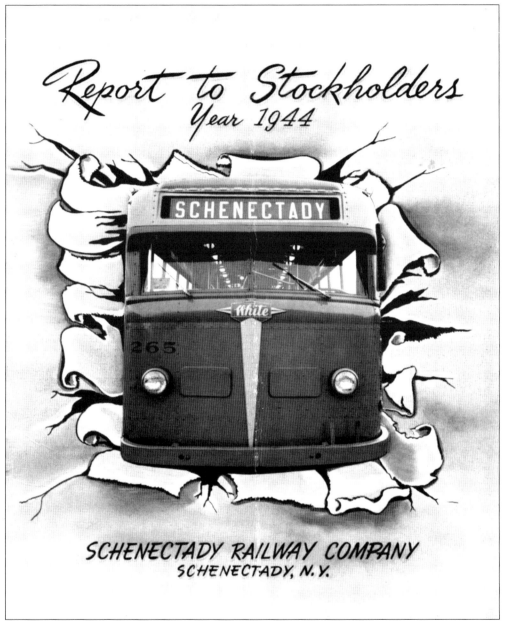

In the 1944 annual report to stockholders, an artist for the Schenectady Railway gave people a glimpse of what was to come. (Nestle collection.)

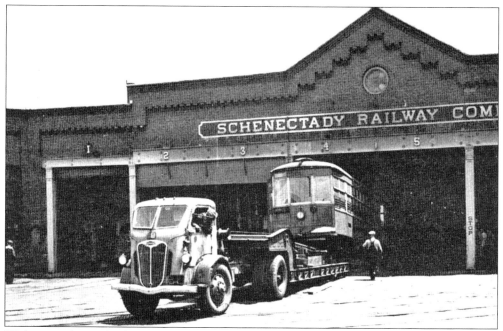

With a war being fought and rubber being rationed, the remaining line of the Schenectady Railway from McClellan Street to the GE works managed to hang around. All was converted to highway buses in August 1946. Seen here is a flatbed truck from Gridley Crane Service of Schenectady removing No. 114 from the barn on its way to a freight yard to be shipped to Santiago, Chile. Former Schenectady historian Larry Hart, who documented all facets of Schenectady life, snapped these photographs as a photographer for Schenectady's *Union Star* newspaper. (Photograph by Larry Hart.)

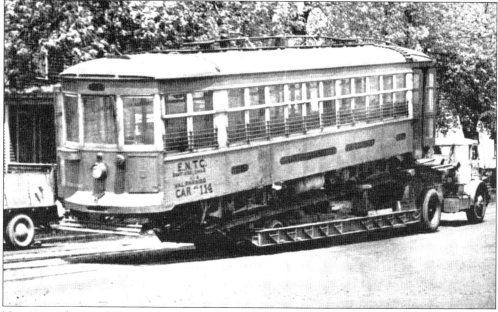

No. 114 makes its last trip down McClellan Street, only this time not of its own power. (Photograph by Larry Hart.)

What once was home to various-size streetcars, the McClellan Street barn became home to the Schenectady Railway's bus fleet. This building was later sold and became the J. M. Fields department store. After that it became a Price Chopper supermarket. (Len Garver collection.)

In the summer of 1992, the former carbarn for the great Schenectady Railway was leveled to make way for a new supercenter supermarket. (Howard C. Ohlhous.)

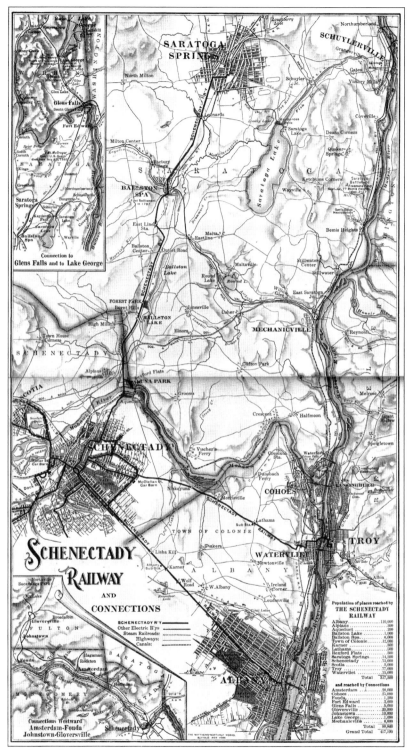

A Schenectady Railway map from the centerfold of its brochure *Trolley Trips in the Hudson and Mohawk Valleys* is seen here. (Smith/Bradford collection.)

Two

UNITED TRACTION COMPANY

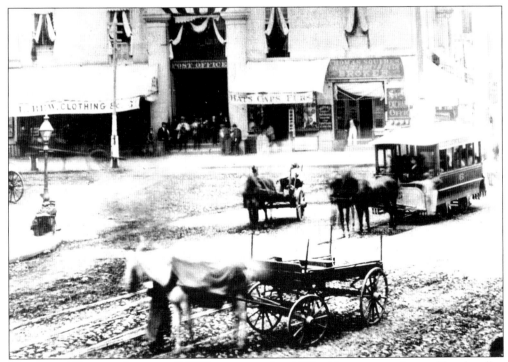

The United Traction Company (UTC) was created in 1899 with a merger of several local trolley lines. Forming the creation were the Albany Railway Company, the City of Troy Railway, and the Watervliet Turnpike and Railway Company. Above is Albany Railway car No. 6 at State Street and Broadway in August 1866. (Fred B. Abele collection.)

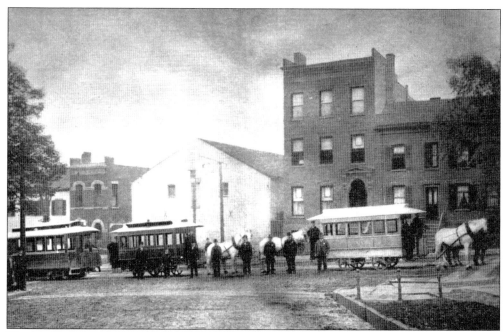

Three horsecars congregate in downtown Albany. The horsecar railroad provided more access to parts of Albany that the steam railroads could not touch. The Albany Railway Company grew out of the Great Western Turnpike Company of 1799 that built Western Avenue and eventually the turnpike to reach central New York. (Fred B. Abele collection.)

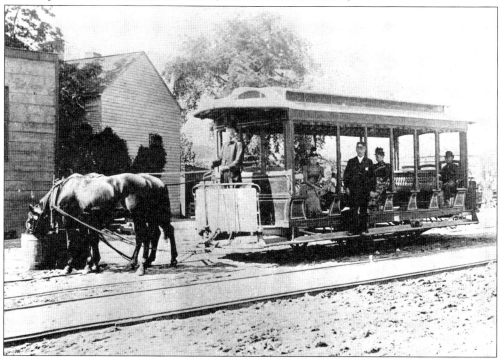

This is the first run of the Watervliet Turnpike and Railway Company in 1890. Its main source of power is seen here grabbing a drink along Troy Road in Menands. (Smith/Bradford collection.)

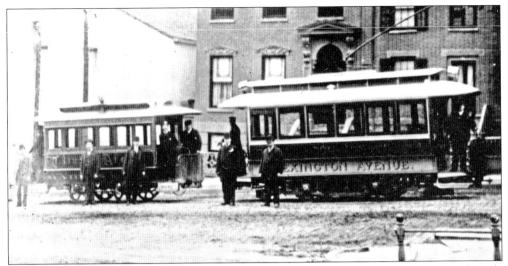

Here is the first electric trolley car in the city of Albany, No. 94. From the name on the side of the car, one can see that it is on the Lexington Avenue line, which is now New Scotland Avenue. (Smith/Bradford collection.)

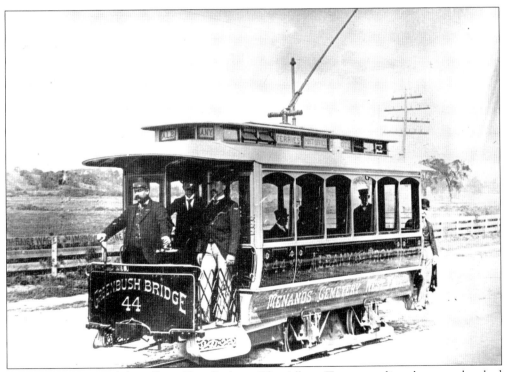

Here is car No. 44 of the Albany-Troy Railway. The Albany-Troy was a line that was absorbed into the Watervliet Turnpike and Railway Company, which merged into the UTC. (Smith/Bradford collection.)

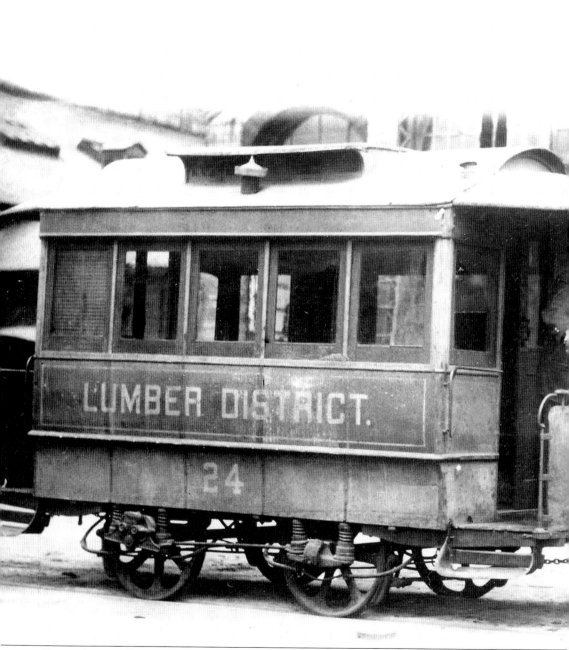

Here is former Albany Railway No. 24 in front of the North Albany carbarn. No. 24 remained in the UTC's system as a shuttle around Albany's vast lumber district. Logs were carried to the

district by the Erie Canal, and they were finished by the sawmills in the lumber district. As of the Civil War, 4,000 sawmills existed in the district. (Fred B. Abele collection.)

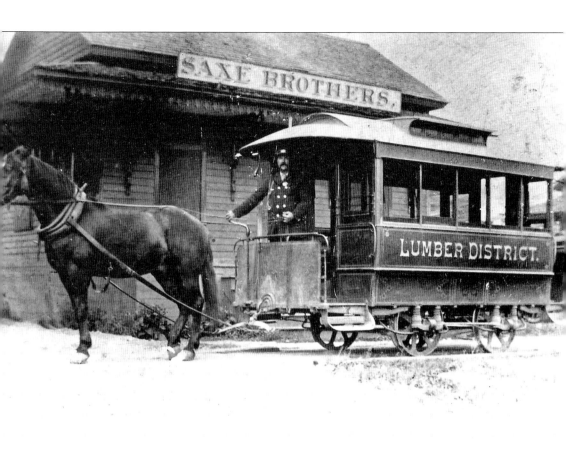

Watervliet Turnpike and Railway Company's No. 28 is seen in front of the Saxe Brothers Company in the Albany lumber district. A Mr. Flynn is the driver. When electrification came to the UTC, the lumber district was one line that was kept as horse-powered. With the size of the district and just enough passengers to make it work, it was deemed too much of an expense to wire the line. The horsecars were efficient and lasted on the line until 1921. A company-wide strike in 1921, which lasted from April to November, ended the life of the horse line. Strikers ripped up several parts of track in the district, and when the strike was over, the UTC forfeited the franchise and it was not rebuilt. (Fred B. Abele collection.)

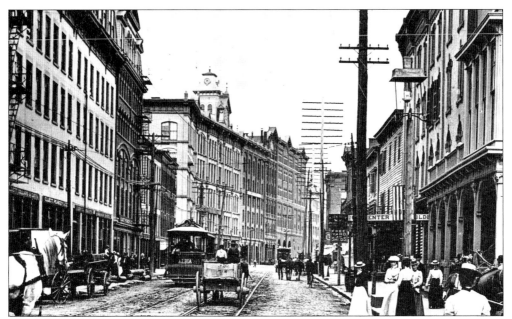

The Troy City Railway (TCR) was made up of several local lines just like the Watervliet Turnpike and Railway Company. The TCR was made up of the Troy and Lansingburgh Railway and Cohoes City Railway. Of course, all these lines merged into the UTC. The car in this photograph is headed to Albia, which was the connection with the Troy and New England Railway. (Nestle collection.)

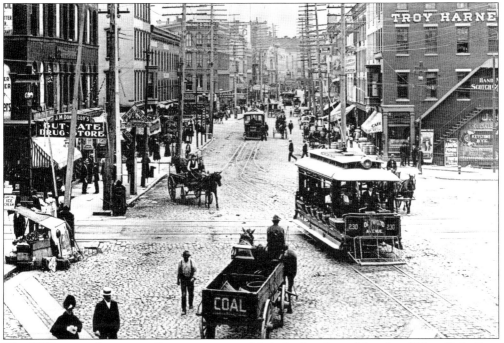

The TCR was a busy one. City streets resembled the hustle and bustle of New York City. Not losing much of its character, several Hollywood movies used downtown Troy to capture early-20th-century Manhattan. (Nestle collection.)

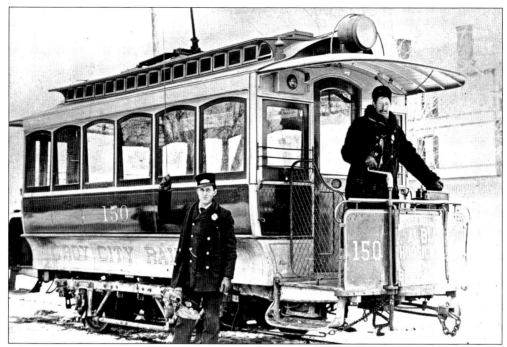

Here is TCR No. 150 on the Albia line. The motorman is a Mr. Hleger, and the conductor is a Mr. Knapper. The motorman's job was an extra cold one in winter, hence the heavy fur coat worn by the driver. (Smith/Bradford collection.)

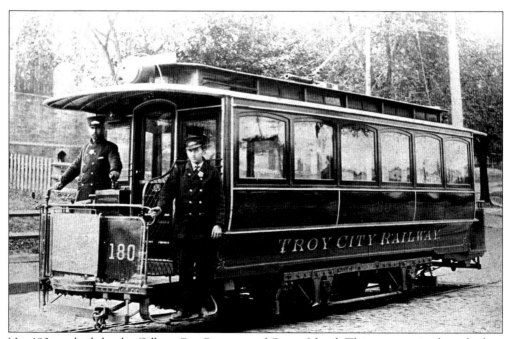

No. 180 was built by the Gilbert Car Company of Green Island. This car remained on the line in the UTC roster. (Smith/Bradford collection.)

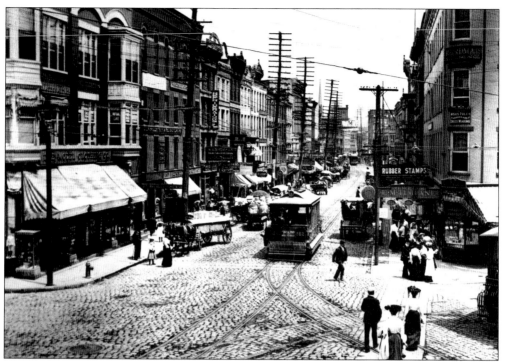

Here are more fabulous shots of the TCR in action. This is car No. 282 heading to the Mill Street line in South Troy. (Nestle collection.)

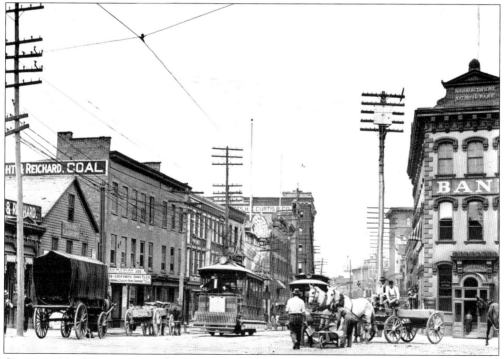

Open car No. 269 is seen in the city of Troy. On the right is Troy's Manufacturers National Bank, which was established in 1864. (Nestle collection.)

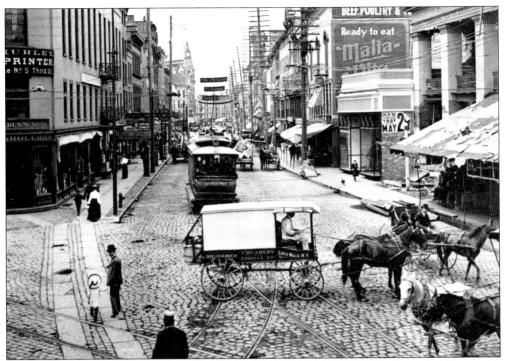

A father hurries his daughter across the street, and a delivery wagon from the Brunswick Creamery and Produce Company of Eagle Mills makes way for an open car. (Nestle collection.)

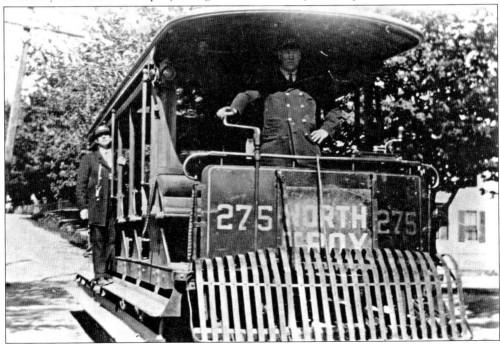

No. 275 makes its way on the "red line" out of the Lansingburgh farm at the end of the line on Mill Street. The conductor is James Harrington, and the motorman is unknown. (Smith/ Bradford collection.)

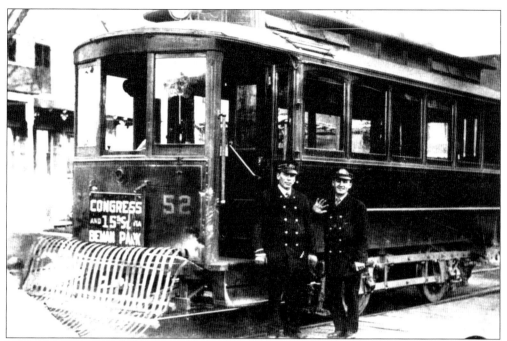

UTC No. 52 was built by J. M. Jones' Sons for the Cohoes City Railway. The UTC later renumbered this car to 32. Conductor Patrick Hughes (left) poses with an unknown motorman at the Albia terminal. (Smith/Bradford collection.)

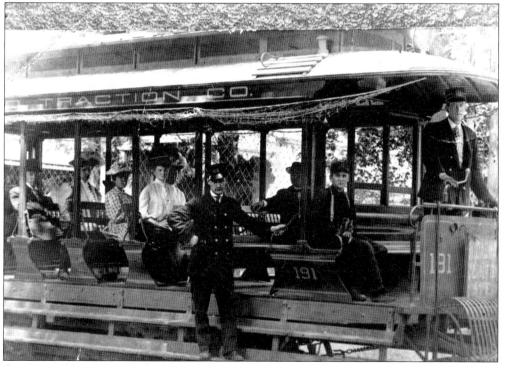

Open car No. 191 was built in 1899 by J. M. Jones' Sons for the Albany Railway. (Smith/Bradford collection.)

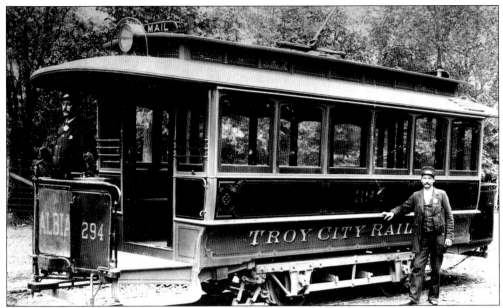

Here is No. 294 in 1897 near Oakwood Cemetery in Troy. The motorman is James H. Smith, whose son Joseph A. Smith built a massive railroad photograph collection. Many of his photographs appear elsewhere in this book. His collection is now in the hands of grandson Kenneth Bradford, who hosts an online archive of the collection. The photograph below also features James H. Smith, this time in running car No. 213 opposite Berman Park. (Smith/Bradford collection.)

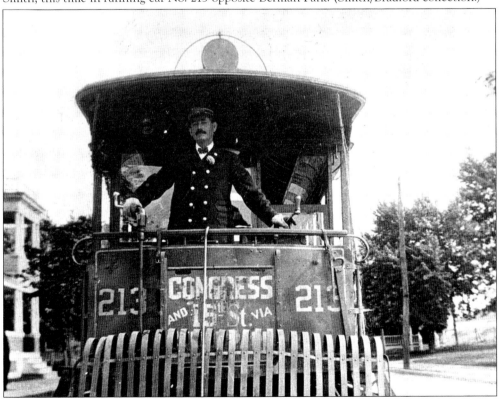

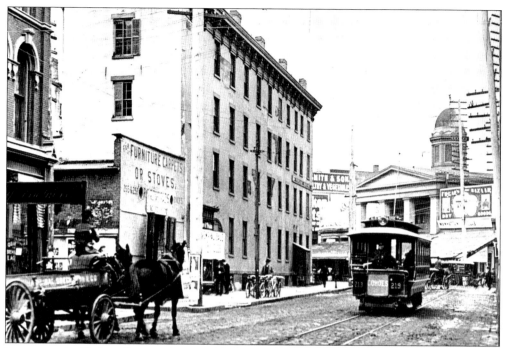

Just across the Hudson River is the city of Cohoes. The Cohoes Railway Company was chartered on July 29, 1894, as the Cohoes City Railway (CCR). A traffic agreement with the UTC was made in December 1899. (Nestle collection.)

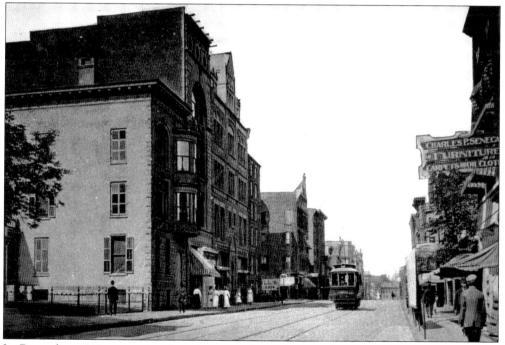

In December 1902, a massive fire wiped out the carbarn and most of the equipment of the CCR. An agreement was then made for the UTC to run its cars on the CCR. (Smith/Bradford collection.)

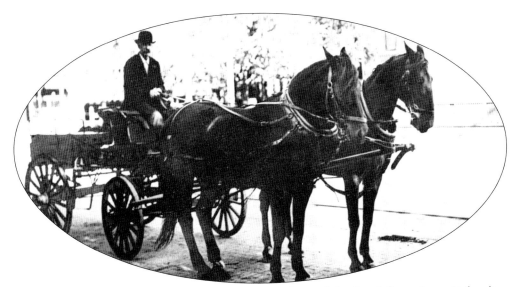

Here is a shot of one of the UTC's repair wagons in front of the Quail Street barn. Before line cars and other utility cars, these horses and wagons were dispatched to the scene of trouble. (Smith/Bradford collection.)

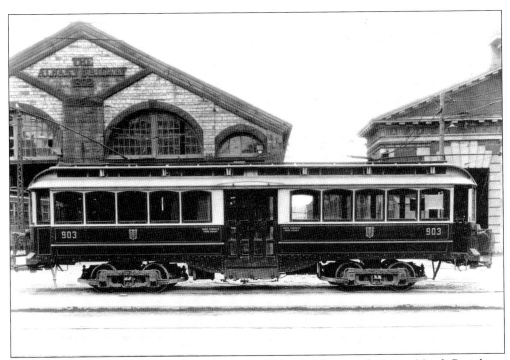

Here is center-entrance car No. 903 in front of the North Albany carbarns on North Broadway. In May 1901, a violent labor strike took place on the UTC, and the New York State National Guard sent 2,500 soldiers to protect the cars of the line. In the vicinity of these barns, a riot took place in which strikers threw rocks at a streetcar, injuring the soldiers and motormen on the car. The soldiers were ordered to fire into the crowd, and two innocent bystanders were killed. The strike was settled on May 18, 1901. (Smith/Bradford collection.)

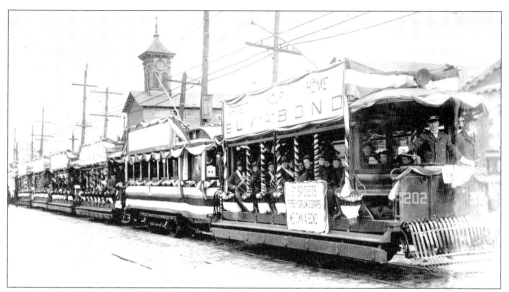

On October 24, 1917, the UTC decorated some of its open cars, filled them with local doughboys, and joined the war bond parade in support of action in World War I. No. 202 takes the lead in the parade in Watervliet. (Smith/Bradford collection.)

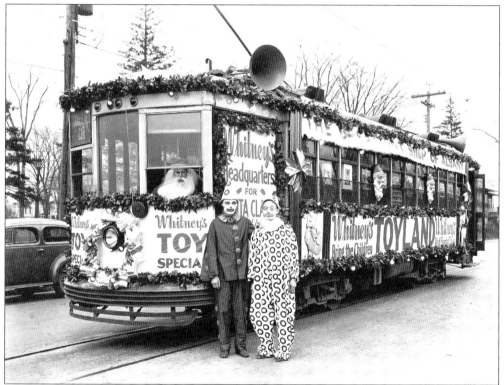

Santa comes to Albany! Arriving by transportation other than his sled, Santa (George Weiland of Albany) comes to town on a car chartered by Whitney's department store in Albany. Whitney's was a well-established business in Albany, opening its doors shortly after the Civil War. (George Whitney collection; Kevin Franklin, Office of the Historian, Town of Colonie.)

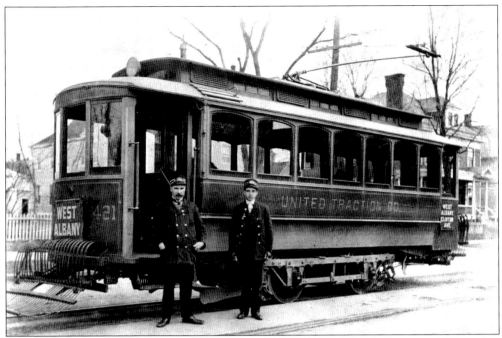

No. 421 is seen with its motorman and conductor at the intersection of Central and Watervliet Avenues in West Albany. A Mr. Fassett, the general superintendant of the UTC, had the opinion that cigarette smoke was bad for one's eyesight. His official orders were that motormen who were heavy smokers were to be given eye exams once a month. (Smith/Bradford collection.)

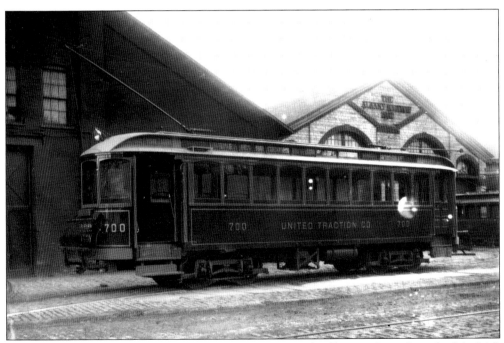

UTC No. 700 sits in front of the former Albany Railway North Albany carbarn. It was built by J. M. Jones' Sons and delivered to the UTC on December 26, 1906. (Smith/Bradford collection.)

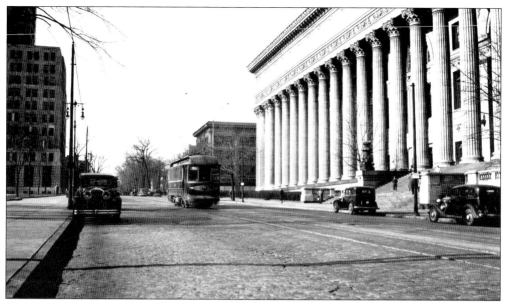

No. 623 makes its way down Washington Avenue in Albany, heading for the state capitol and State Street Hill. The UTC took good care of its equipment, and motormen knew to be extra careful coming down a hill like this. If a motorman was involved in an accident with another trolley, wagon, or car, it usually meant termination. (Nestle collection.)

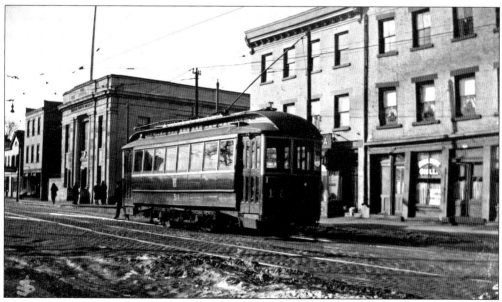

No. 15 stops at the intersection of Quail Street and Central Avenue so its motorman can turn the switch to head down Quail Street. The bank in the background has now been restored as the Linda, WAMC public radio's performing arts center. (Nestle collection.)

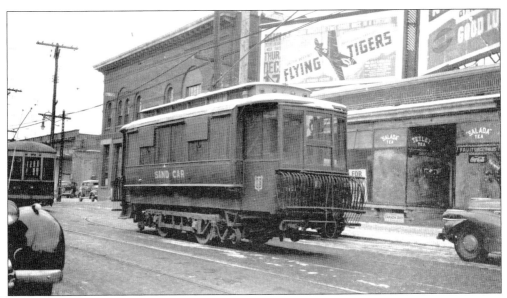

Here is sand car No. 121 on Quail Street in Albany. This car was built from an old city car by the UTC's shops. Sand cars were important for providing traction on the many hills of downtown Albany. (Smith/Bradford collection.)

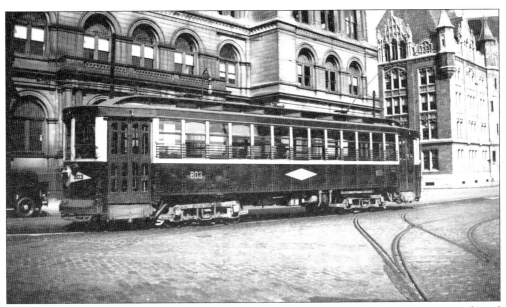

Here is No. 803 near the post office in Albany. No. 803 was part of a lot of 11 cars purchased from the Pressed Steel Car Company of Pittsburgh, Pennsylvania, in 1911. This car was built for two-man operation, but with cost cutting it was changed to a one-man operation. The cars started as belt line cars in Albany and were converted to make the Albany-to-Troy runs. (Nestle collection.)

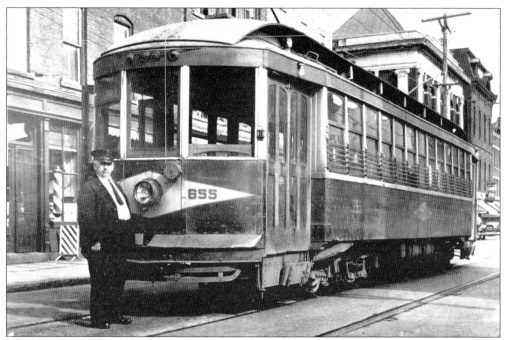

UTC No. 655 was built in 1918 from a Hudson Valley open car. The UTC became the operator of the Hudson Valley Railway and helped with equipment on many occasions. When the Hudson Valley Railway abandoned cars, some made their way to Albany. (Smith/Bradford collection.)

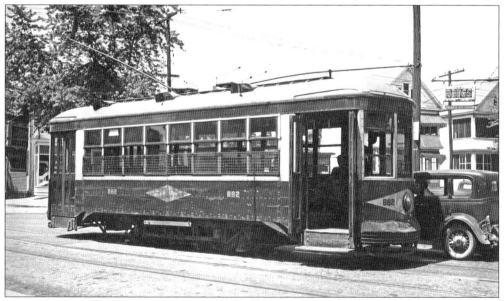

Here is the owl car. UTC No. 862 stops on the Delaware Avenue line in the 1940s. Twenty-five UTC cars numbered 851 through 875 were run on the Albany belt line (and some others) after hours and all night. These single-truck cars had wooden-slat seats, which made for an uncomfortable ride, especially on bumpy roads. (Author's collection.)

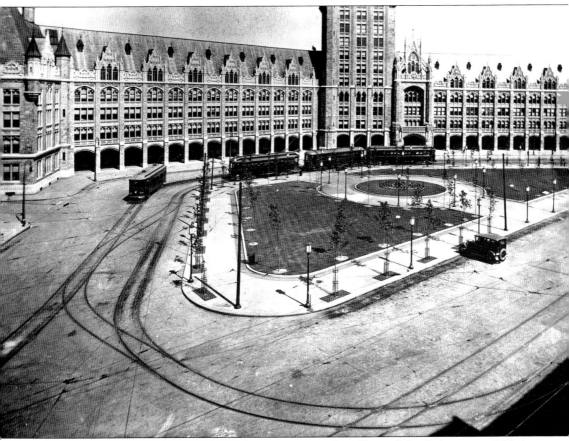

Here is a row of cars waiting for work to get out at the offices of the Delaware and Hudson Railroad. This is the loop that several companies used to turn their cars around and then head back to their home lines. Both the Schenectady Railway and the Albany Southern Railroad used this trackage to return both east and west to Schenectady and Hudson. (Nestle collection.)

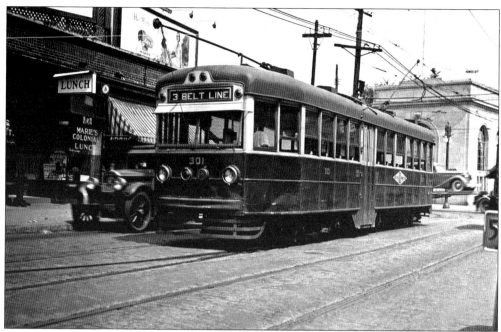

No. 301 was a prototype car acquired by the UTC in the 1930s, and it was built by the Cincinnati Car Company in 1929. The UTC had plans to purchase many cars like this, but a change in management and the onset of the Great Depression made this the last car ever purchased by the company. This and a sister car were unique in the fact that they were controlled by a foot accelerator, not much different from an automobile. Most trolley cars were run using hand controls. Below, No. 301 is seen in front of the carbarn on Quail Street. The driver who spent the most time in it was Harold Wicks, seen behind the controls. It was a favorite car of fan trips and served the line up until abandonment in August 1946. (Nestle collection.)

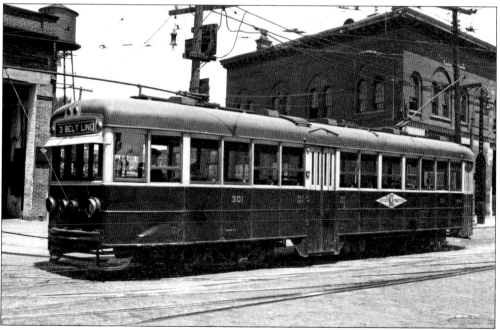

It is a quiet day in a usually busy downtown Albany. The view down State Street Hill shows a lone car making its way up from the Delaware and Hudson building. This building is now the New York State Department of Education. (Nestle collection.)

Route No. 2 was the West Albany line of the UTC. Car No. 623 is turning left onto Central Avenue on its way from Watervliet Avenue. The No. 2 line served the very busy West Albany yards of the New York Central Railroad. The route was abandoned on August 10, 1946. (Nestle collection.)

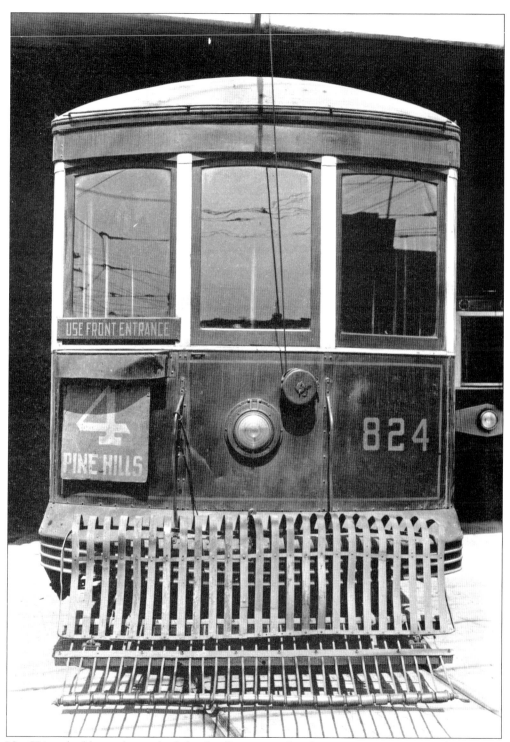

No. 824, a double-truck unit built by the Cincinnati Car Company in 1913, sits in front of the Quail Street barn. Equipped with the standard safety device on its front, No. 824 ran on the Pine Hills line until it was abandoned on August 10, 1946. (Nestle collection.)

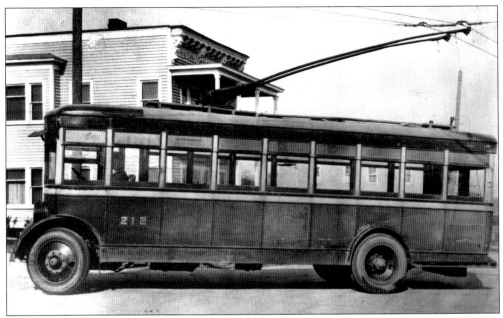

When lines of the UTC started to be abandoned in the 1920s, buses took the routes over. In a proposed 10-year experiment, trolley buses like No. 212 above were used on the Cohoes line, receiving power from a series of four overhead wires. Firemen from the Cohoes Fire Department complained that these overhead wires made it difficult to fight fires, and the buses were removed from service. Diesel buses were substituted on the line. (Smith/Bradford collection.)

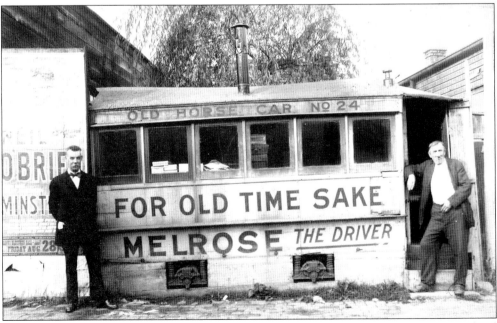

Former horsecar No. 24 was converted to a diner on Quail Street in Albany. Streetcars and rail passenger cars have always been popular for converting to roadside eateries. Car No. 24 is now preserved and on display at the New York State Museum in Albany. (Fred B. Abele collection.)

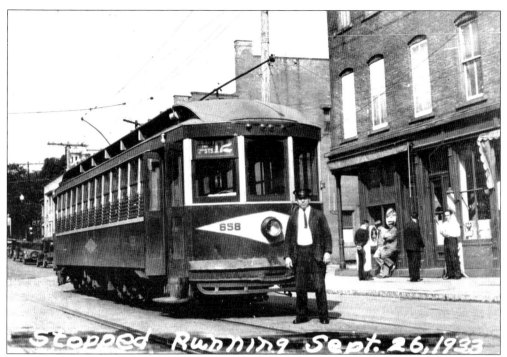

The No. 12 Waterford–Thomas Street line was abandoned on September 26, 1933. Car No. 658 is on Broad Street heading back to the Lansingburgh barn, just across the bridge from Waterford. (Smith/Bradford collection.)

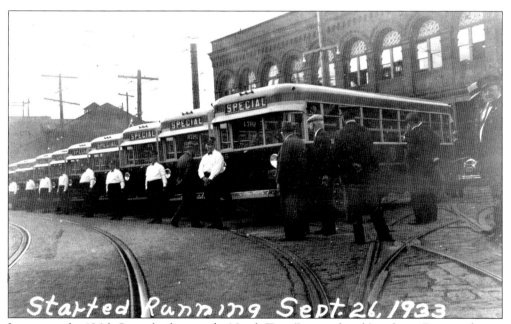

Just across the 126th Street bridge was the North Troy (Lansingburgh) carbarn. Buses took over the line and started running to Waterford, Cohoes, and Troy. With the institution of bus service in these areas, it left the UTC as an Albany-only trolley line. (Smith/Bradford collection.)

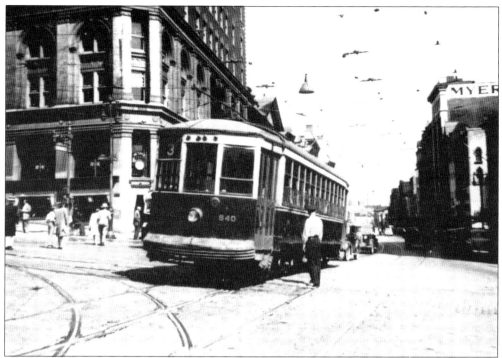

These photographs are from the last days of traction service in downtown Albany. The date is August 31, 1946, and No. 840 heads southbound on Pearl Street, crossing State Street. August 10 of the same year saw four other lines in Albany close, Pine Hills, West Albany, Delaware Avenue, and Second Avenue. Below is the last car to run on the city line; No. 834 is seen leaving the Quail Street barn. And so ended 56 years of electric streetcar operation in Albany. (Above, Fred B. Abele collection; below, Smith/Bradford collection.)

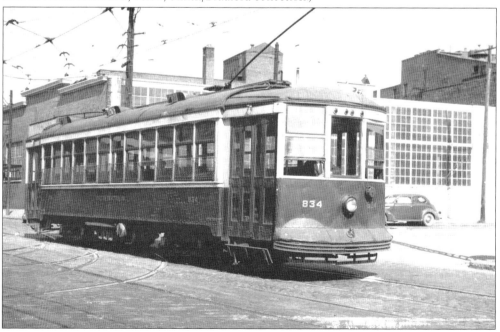

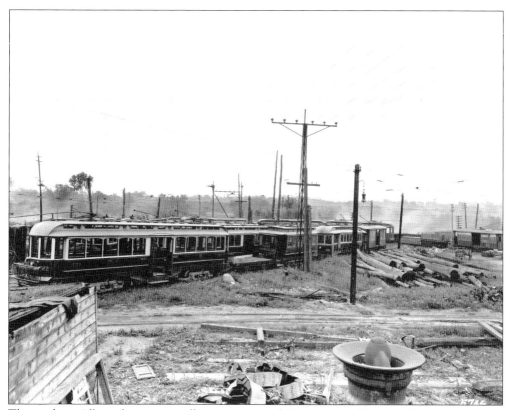

The yards in Albany became a trolley car graveyard. Passenger trolleys as well as various work cars sit and wait their turn with the wrecker's torch. Salvageable material was stripped from the cars, and then the car bodies were torched. (Nestle collection.)

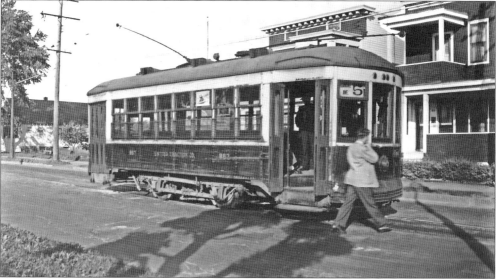

Pictured here is the last stop on the Delmar line as No. 867 makes one last trip on Delaware Avenue on June 9, 1946. Bill Knapp, a local railfan, exits the car on the historic occasion. (Author's collection.)

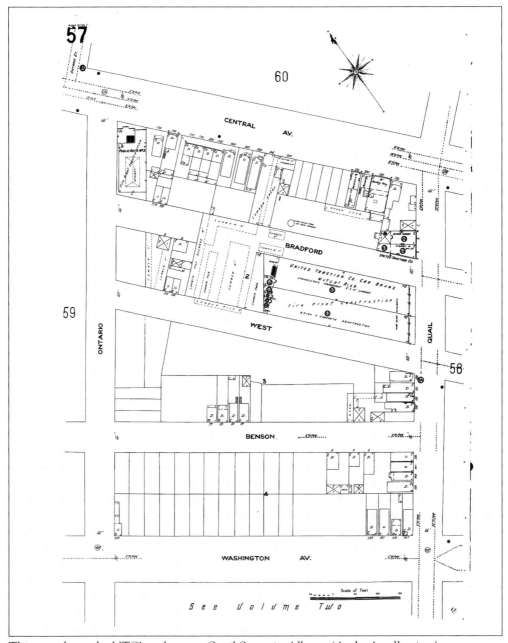

This map shows the UTC's carbarn on Quail Street in Albany. (Author's collection.)

Three

HUDSON VALLEY RAILWAY

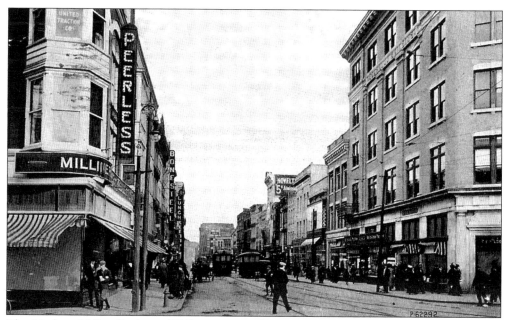

The Hudson Valley Railway (HV) was a conglomeration of several lines that totaled over 100 miles of track between Troy and Warrensburg in Warren County. The city of Troy was the southernmost stop on the line. A busy River Street is seen here in the early days of the trolley line. (Author's collection.)

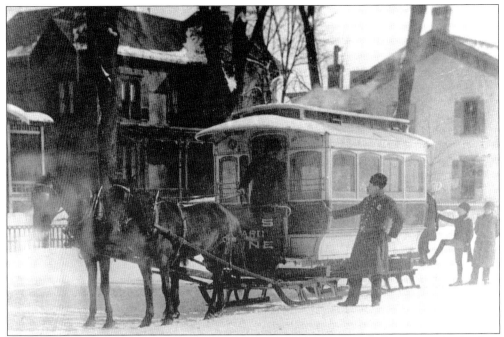

Glens Falls, known for its fair share of snow, substituted sleigh tracks for horsecar wheels when the conditions were deemed too tough. Glens Falls, Sandy Hill and Fort Edward No. 5 is seen here on Glen Street in 1888 using its sleds to guide its way along the right-of-way. (Smith/Bradford collection.)

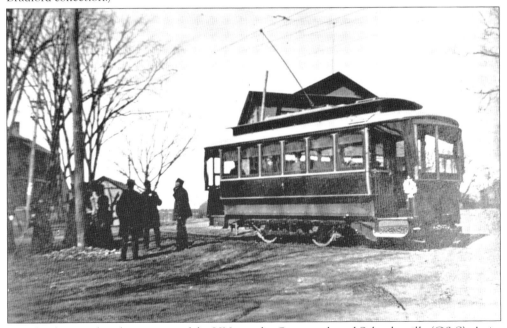

Another line used in the creation of the HV was the Greenwich and Schuylerville (G&S). As its name implies, it ran between these villages, making its way through Thompson on the Hudson River and Middle Falls on the Battenkill. G&S No. 1 is seen in Middle Falls after the opening of the line. The conductor for the trip was Fred Stiles. (Smith/Bradford collection.)

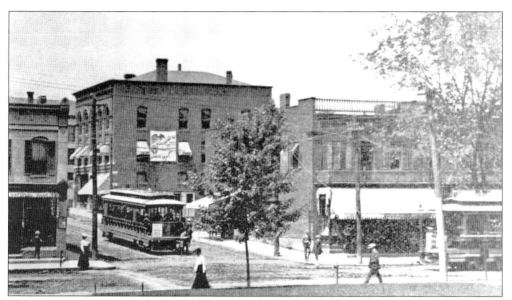

The Stillwater and Mechanicville Street Railroad ran between these two towns, Mechanicville being the bigger of the two. Car No. 24 is seen coming down to the intersection of Park Avenue and Main Street, while a Stillwater car arrives on the right. (Smith/Bradford collection.)

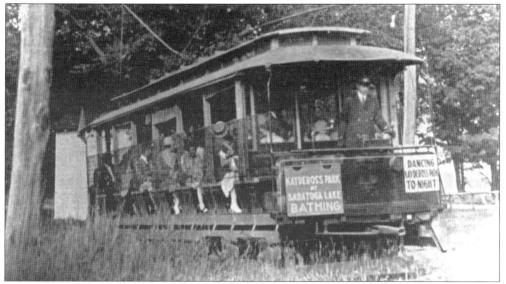

The Saratoga Electric Railway was a consolidation of several trolley roads before it was combined into the HV system. It was chartered in July 1889 and in 1890 built its road between Saratoga Springs and Geysers (present-day Spa State Park at Saratoga). The Union Electric Railway and the Saratoga Lake Railroad combined to form one big Saratoga Traction Company. No. 177, an open car of the Saratoga Lake Railroad, is seen leaving Saratoga Lake on its way back to the springs from the new terminal at Kaydeross. (Smith/Bradford collection.)

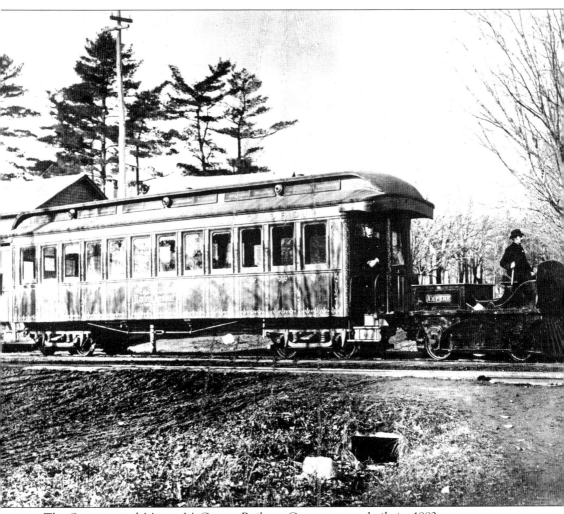

The Saratoga and Mount McGregor Railway Company was built in 1882 as a narrow-gauge steam railroad with hope of extending from Saratoga Springs to Lake George. The line only made it to Mount McGregor, a distance of 10 miles, and a hotel was built at the end of the line. This is the railroad that carried the body of Pres. Ulysses S. Grant on his funeral train in 1885. Seen above is one of America's first electric locomotives, called the *Ampere*, being tested on the line. Leo Daft is showing off his invention on November 24, 1883. Eventually this line would become electrified as the Saratoga and Northern Railway, which in turn became property of the HV. (Frank Dodge collection.)

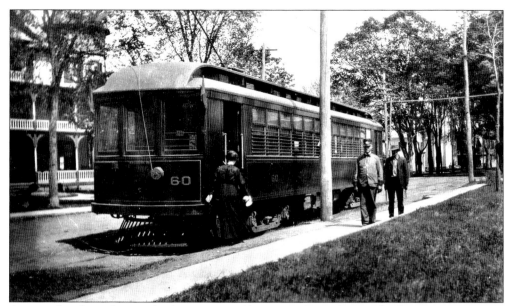

A new railroad was chartered to be constructed between Warrensburg and Lake George in January 1900. That request was not granted, but a charter connecting Glens Falls with Warrensburg by way of Lake George was approved as the Warren County Railroad. Seen here is car No. 60 at the end of the line in Warrensburg. (Smith/Bradford collection.)

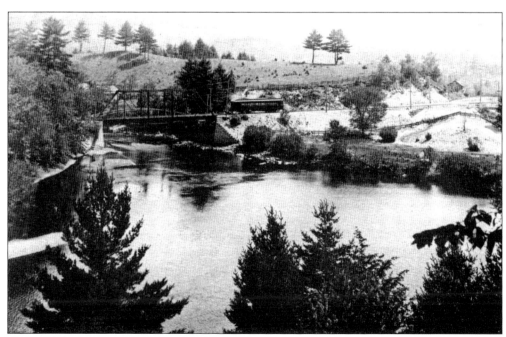

A car of the Warren County Railroad/HV is seen getting ready to cross the Schroon River bridge on its way to Warrensburg. (Author's collection.)

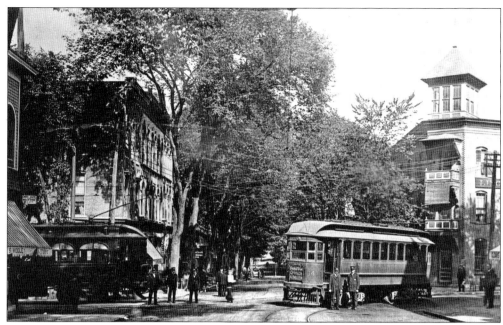

One of the first extensions for the new HV was a piece of Saratoga Traction that went into Ballston Spa. Here is a view of Lincoln Square and an HV car turning onto Milton Avenue. The car on the left is a Schenectady Railway interurban getting ready to turn down Milton Avenue. In the early days of the HV and Schenectady Railway Company, no connection was made with either line, but after the Delaware and Hudson Railroad acquired a share in both lines, they were consolidated through Ballston Spa. (Smith/Bradford collection.)

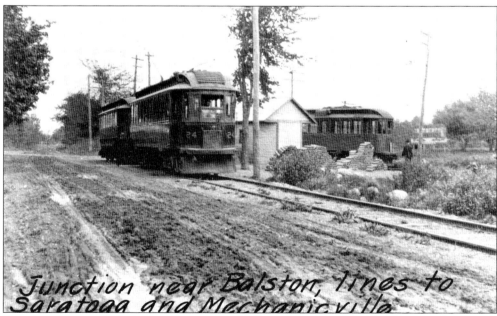

Cars from Troy and Mechanicville arrive at Ballston Junction. The No. 24 is heading north to Saratoga Springs, and the car on the right is heading down Malta Avenue on its way to the village of Ballston Spa. (Smith/Bradford collection.)

The "Queen of the Spas," Saratoga Springs was a popular destination on the HV. Before they had a legitimate passenger depot, the former Saratoga Traction's passengers bought tickets from a newsstand/lunch counter located between the grand hotels of the "Spa City." (Saratoga Springs Public Library.)

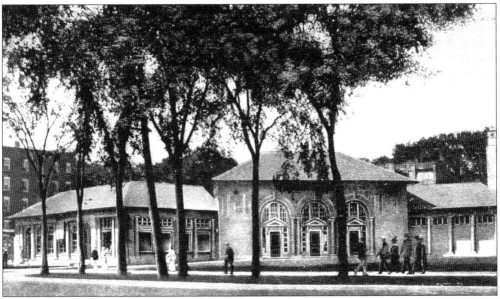

Originally the HV and its predecessor were prevented from building tracks across Broadway. Riders had to exit cars at Congress Street and then walk a few blocks to catch either a northbound car for Lake George or an eastbound car for the Saratoga flat track or Saratoga Lake. Permission was finally given to cross Broadway and connect the lines after a deal to build an elaborate depot was made, and on April 20, 1916, the official opening of this depot was celebrated. Today this beautiful building exists as the Saratoga Springs Visitor Center on the corner of Congress Street and Broadway. (Saratoga Springs Public Library.)

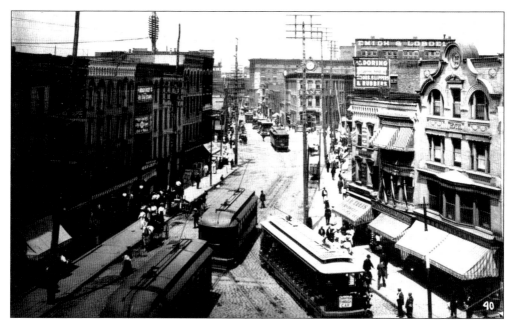

Franklin Square in Troy was the epicenter of Capital District trolley transportation in 1904. The big three lines, UTC, Schenectady Railway, and HV, all met in this location. HV No. 124 is on the right getting ready to head north to Waterford, Mechanicville, and Saratoga Springs. The sign on the front of the car reads, "Saratoga Through Car," the name that late author David F. Nestle chose for his book on the history of the HV. (Smith/Bradford collection.)

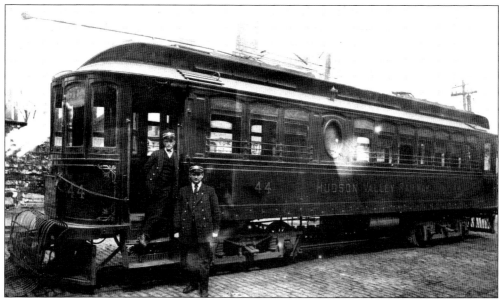

HV No. 44 made the long trip from Troy to Warrensburg a comfortable one by having modern conveniences. One such benefit was a restroom located where the round window is in the center of the car. The State of New York made it a law that bathroom facilities must be provided on any trip over 40 miles. (Smith/Bradford collection.)

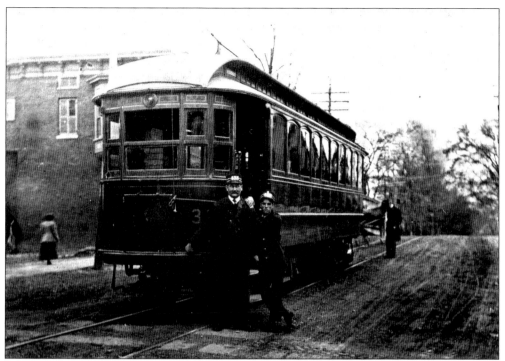

No. 32 is seen here at the Delaware and Hudson Railroad crossing in Fort Edward. An old-time motorman is joined by his much younger conductor. (Smith/Bradford collection.)

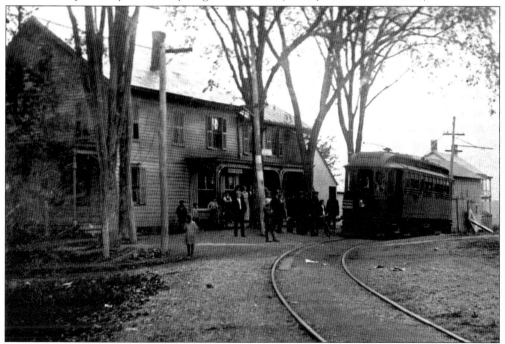

Post office/general stores were busy places in these Upstate New York towns. A car has just made its way up from Thompson on the former G&S, and a big Middle Falls crowd gets ready to board the car. (Smith/Bradford collection.)

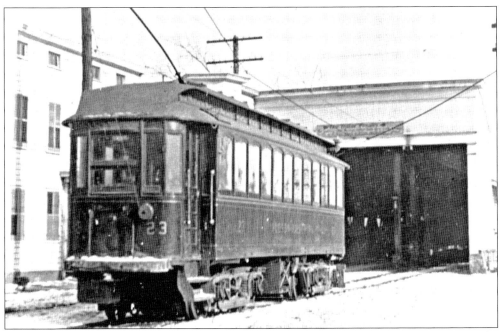

HV No. 23 makes its way across the old 800-foot Troy/Waterford covered bridge. This was the official beginning of HV trackage, but the UTC, which was part owner of the HV, used the line to access its Waterford line. This bridge was built in 1804 by famous bridge designer Theodore Burr, and it burned in a spectacular fire in July 1909. (Smith/Bradford collection.)

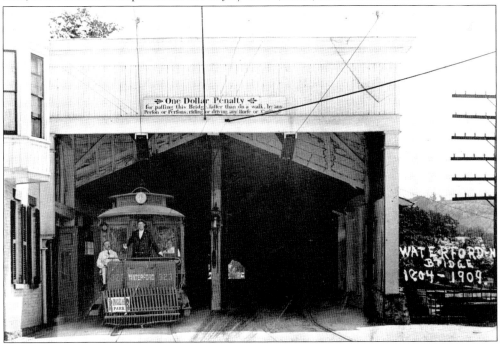

Here is the front of the bridge with a UTC Waterford car posing for the photograph. The sign on the front of the bridge warns of the dangers a pedestrian might encounter walking across the bridge and the subsequent fine. (Smith/Bradford collection.)

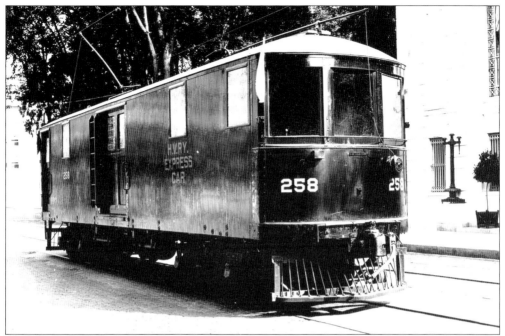

Express car No. 258 makes its way down Glen Street in Glens Falls delivering goods. The HV, UTC, and Schenectady Railway Company combined to create the Electric Express Agency to deliver parcels along their lines. This came in handy during the slow winter months when passenger service dropped off. (Smith/Bradford collection.)

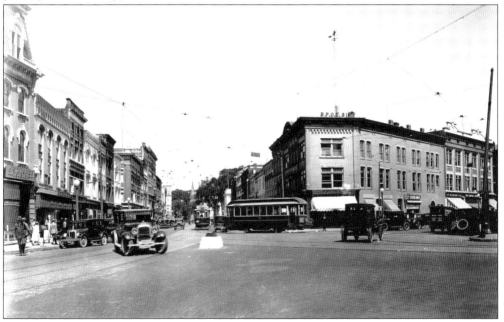

Here are cars No. 12 and No. 30 at the busiest intersection in Glens Falls, the intersection of Main, Ridge, Warren, and Glen Streets. The car in the center is heading toward Hudson Falls and Fort Edward. Today this intersection is just as busy, but a roundabout has been constructed and it is named Centennial Square. (Smith/Bradford collection.)

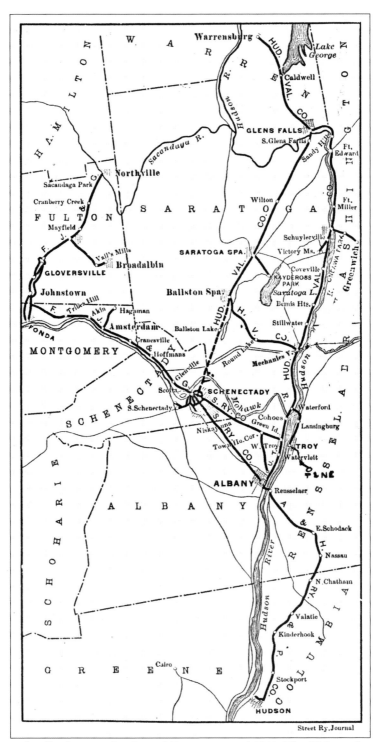

Here is a map of trolley lines in the Capital District around 1911. The HV stands out at the top right as making a loop between Troy, Lake George, Ballston Spa, and Mechanicville. Spurs are shown to Greenwich, Saratoga Lake, and Warrensburg. (Len Garver collection.)

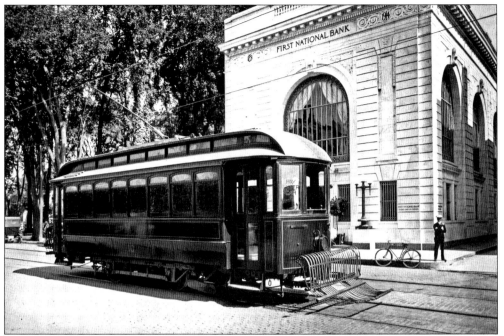

HV No. 5, a local product from J. M. Jones' Sons, poses in front of the First National Bank building on Glen Street. The South Street line ran by this location. Even with new construction in the area, this building remains to this day, also as a bank. (Smith/Bradford collection.)

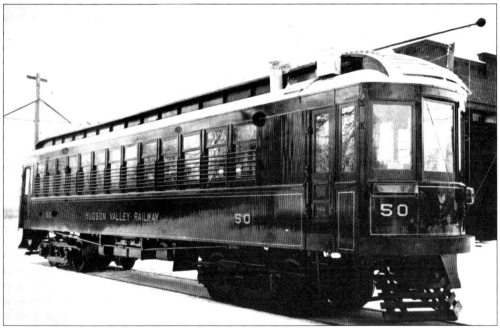

No. 50 sits outside the Queensbury carbarn in this winter shot. No. 50 was equipped with a slot on its front for the loading of coffins into the trolley. Before the use of motorized hearses and after the horse-drawn variety, trolleys were a good source of funeral transportation. (Smith/Bradford collection.)

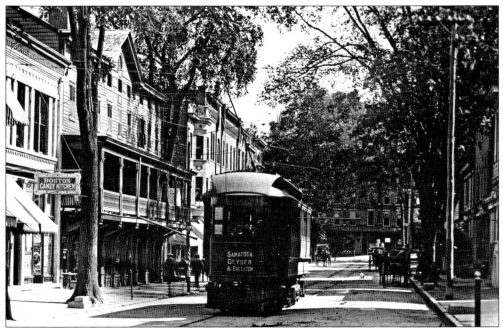

A Ballston/Geyser car arrives at the HV station on the corner of Front Street and Bath Street in Ballston Spa. To the left of the car is the Medberry Spa. The HV and Ballston Terminal Railroad lines ended at this point. Bath Street was a very steep hill, and the Ballston Terminal's cars did not venture up it much. In later days, the Schenectady Railway's line joined up with the HV. After the Delaware and Hudson Railroad took control of both the Schenectady Railway Company and HV, both trolley lines shared trackage to share expenses. (Smith/Bradford collection.)

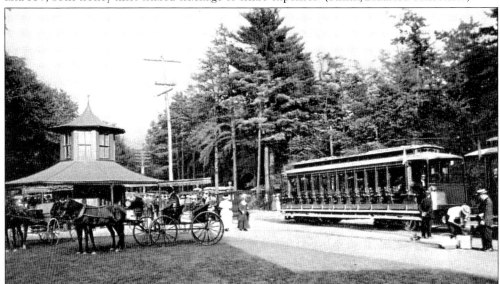

Just as popular 100 years ago as it is today, the world-famous Saratoga Race Course has been entertaining fans for almost 140 years. Limited cars were run from all over the Capital District to drop off race fans at the front gate. In this view, two HV open cars wait for their passengers after a long day of wagering and sampling local mineral waters. This location would be present-day Union and East Avenues. (Saratoga Springs Public Library.)

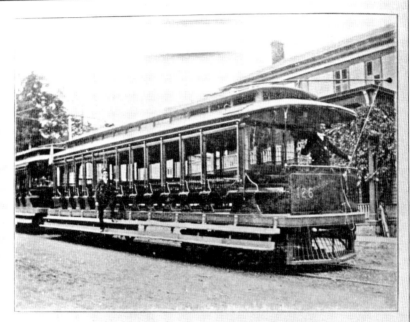
This advertisement shows an HV car built by the J. M. Jones' Sons car works. J. M. Jones' Sons was founded in Watervliet in 1864 as Jones and Company. It was created by J. M. and Richard Jones to build wagons, which they sold all over the country. J. M. Jones' Sons Company succeeded Jones and Company in 1874, building many electric cars before ceasing production in 1912. It is said that at one time the company produced 300 trolley cars a year. (Smith/Bradford collection.)

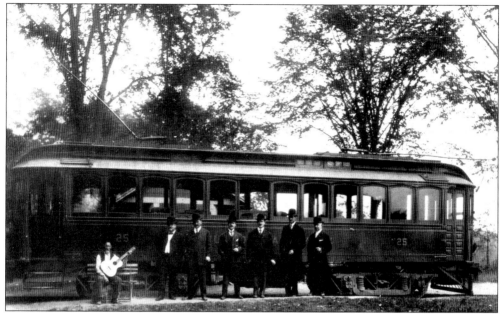

The HV's board of directors poses at the depot on Saratoga Lake. The HV ran two parks on the line. One was Kaydeross Park left over from the Saratoga Lake Railway days, and the other was Ondawa Park near Greenwich. The man on the guitar is local legend Joe "Pop" Nickerson. Pop came to Saratoga Lake in the early 1900s and greeted many a trolley patron as they detrained near the depot. (Smith/Bradford collection.)

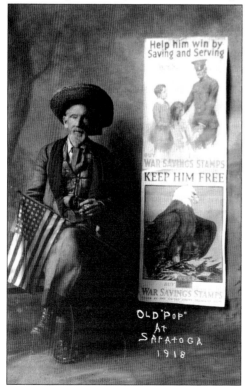

Pop ran a souvenir stand at the end of the trolley line to the lake and handed out loads of free advice at his famous "Walled-Off Astoria." Many postcards were created to promote Saratoga Lake's famous resident. He also provided commentary for local Saratoga newspapers. (Saratoga Springs Public Library.)

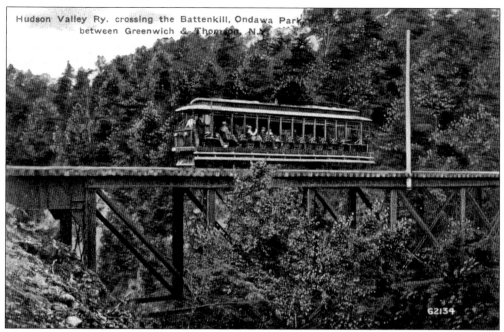

Ondawa Park was located on the G&S near Middle Falls. It featured a dancing pavilion, bicycle track, and croquet ground. Another attraction was the view of Dionondahowa Falls on the Battenkill, which the open car above is crossing. (Author's collection.)

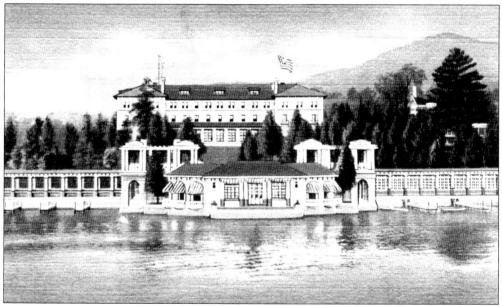

The Fort William Henry Hotel was owned by the HV and could accommodate 800 patrons. The hotel was built near the ruins of old Fort William Henry, a military outpost from the French and Indian War. The hotel was accessed by HV trolleys as well as passenger trains of the Delaware and Hudson Railroad's Lake George branch. The HV eventually sold the hotel in 1925, but it remains open today. In this postcard, the hotel is backdropped by Prospect Mountain. Prospect Mountain was reached by a cable railway pulling cars to the summit. (Author's collection.)

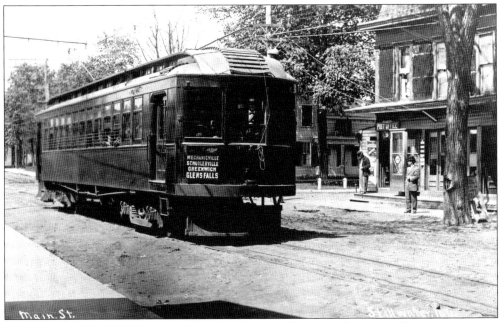

Cruising along Main Street in Stillwater, HV No. 52 passes the post office on its way to Schuylerville. Between Schuylerville and Stillwater is the historic Saratoga Battlefield, site of what historians say is the battle that changed the course of the Revolutionary War. (Smith/Bradford collection.)

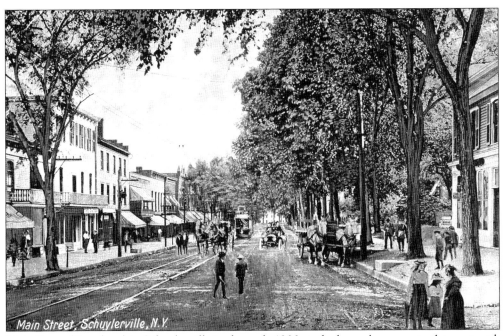

Main Street (Broadway) in Schuylerville in the early 1900s is the busy place seen in this postcard. This was the home of Gen. Phillip Schuyler, a Revolutionary War general. Some of the old trolley tracks still poke through Route 32 today. (Saratoga Springs Public Library.)

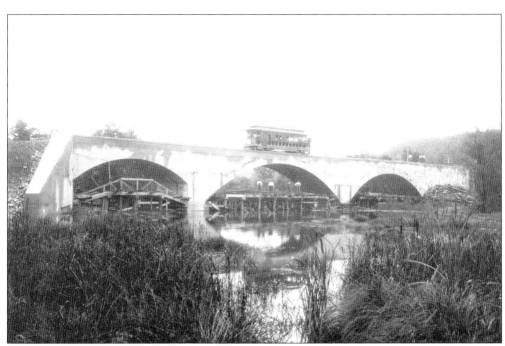

An open car leaves Mechanicville and crosses the stone arches at Willow Glen. This viaduct carried the HV over a swamp and the main lines of the Delaware and Hudson and Boston and Maine Railroads. (Smith/Bradford collection.)

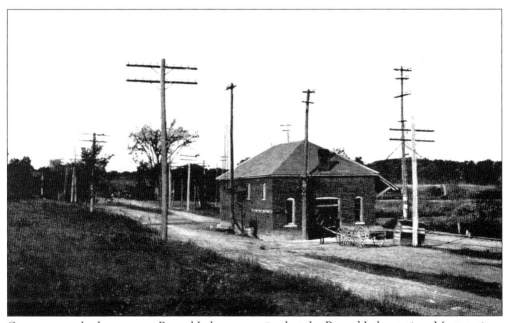

Once one made the curve at Round Lake, one arrived at the Round Lake station. Most stations on the HV were stone structures like this. Today this is New York State Route 9 looking north. (Author's collection.)

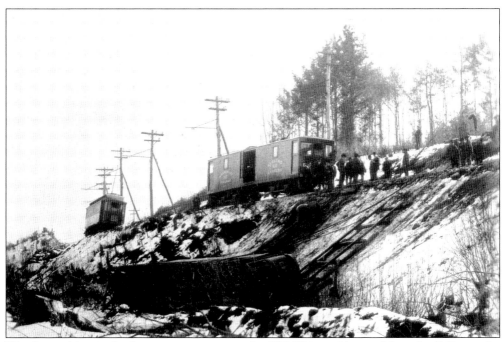

Wrecks resulting in death were no stranger to the HV. This accident at Mosquito Falls, on the Lake George branch, saw No. 40 take a tumble down a ravine after the sandbank gave away. Amazingly, no one was killed in this wreck, but the motorman was pinned under a stove. In the photograph above, a work car comes to the rescue, and below, No. 40 has been pulled back onto the line. (Smith/Bradford collection.)

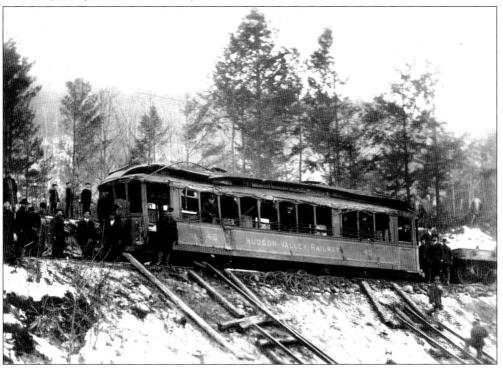

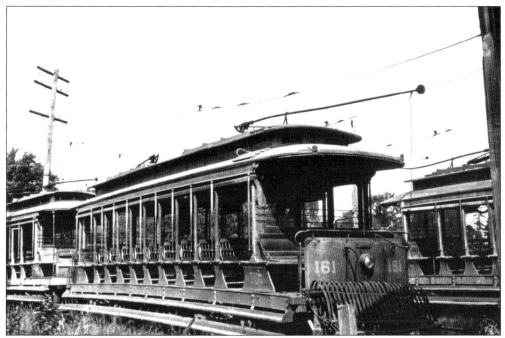

The end came quickly for the HV. The first to go was the Saratoga Lake line in 1925. Above are the open cars used on the line sitting ready for scrap at the Saratoga carbarn at the end of August of the same year. (Smith/Bradford collection.)

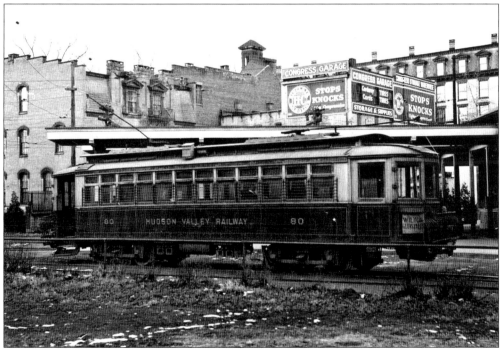

Next was the Saratoga belt line on January 20, 1926. All other lines followed. Above is car No. 80 in Saratoga Springs the day before total abandonment, November 30, 1928. (Smith/Bradford collection.)

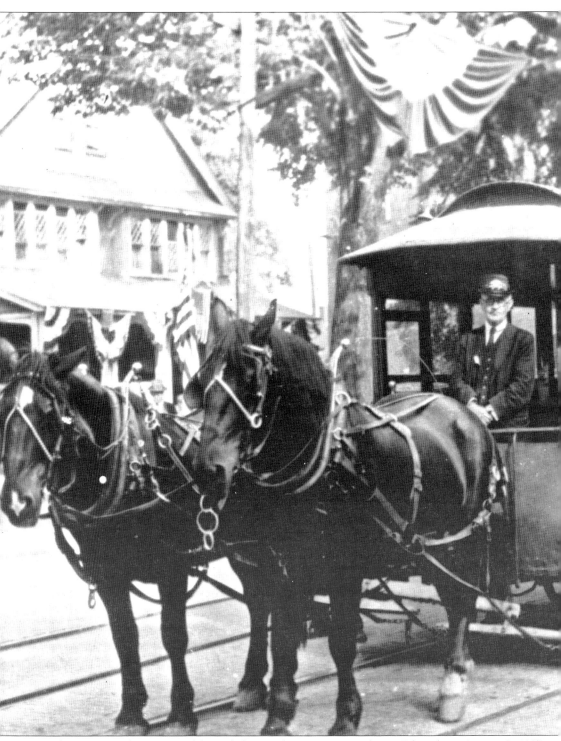

The Pageant of Progress celebrated the 100th anniversary of Fort Edward on August 3, 1927. Former horsecar No. 24 of the UTC was brought out of storage to mark the celebration, seeing its first action since the 1921 trolley strike in Albany. John Laughlin holds the end of the reins. Behind

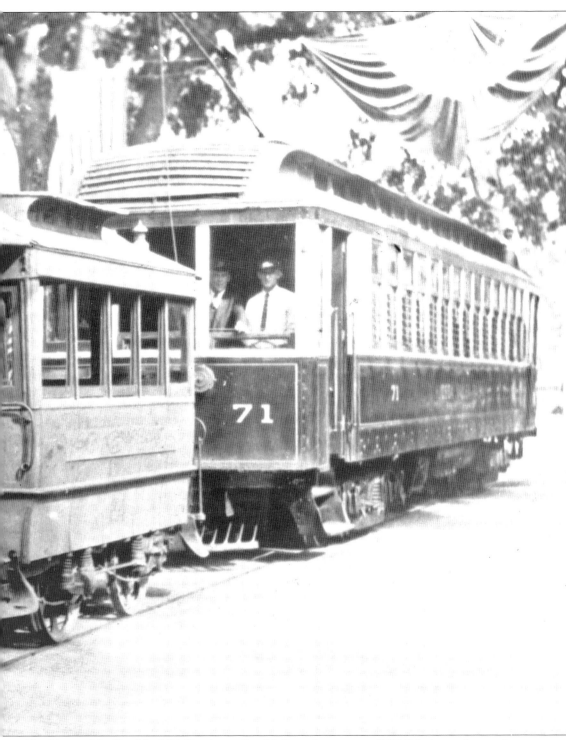

No. 24 is car No. 71 of the HV. Conductor Roy Vaille and motorman Bill Nichols run the car. Just a short year later, the Stillwater–Fort Edward line would be abandoned and so would all of the HV system. This car and others in the fleet would then be burned. (Smith/Bradford collection.)

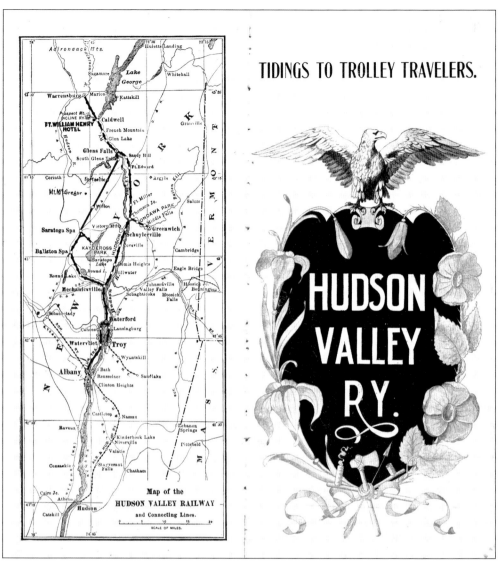

This brochure was printed by the HV to promote its railroad and the sights along the line. Also promoted were the services of its four-star hotel at Fort William Henry and the recreation of Kaydeross Park. (Smith/Bradford collection.)

Four

ALBANY SOUTHERN RAILROAD

The Albany and Hudson Railroad made its debut in 1880 as a steam line called the Kinderhook and Hudson. It first ran from Hudson to Niverville where it made a connection with the Boston and Albany Railroad. After a falling out with the Boston and Albany in 1899, the company was reorganized as the Albany and Hudson Railroad. The line was extended to Rensselaer and was electrified using a third-rail system. In the photograph above, No. 24 is seen at the Rensselaer dispatcher's office getting ready to make the trip south to Hudson. (Smith/Bradford collection.)

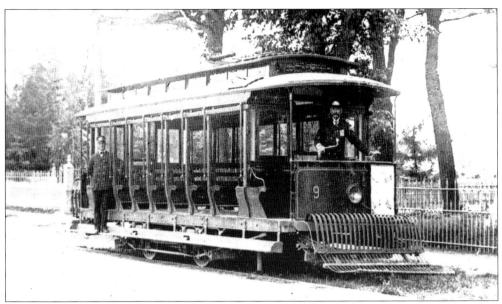

Open car No. 9 was built for the Albany and Hudson Railroad between 1890 and 1899. Open cars in this series were limited to Hudson locals, as the officers of the company worried that high speeds used between Albany and Hudson might cause a dangerous situation. The open doors caused concern that passengers might fall out. The company also said the open feature of these cars was not necessary in the summer months when the high rate of speed attained by the closed cars like No. 302 below would be enough to cool off hot passengers. (Frank Dodge collection.)

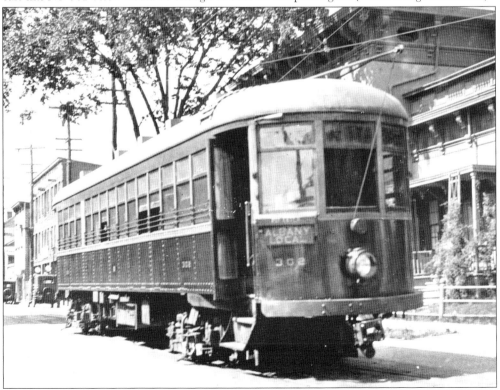

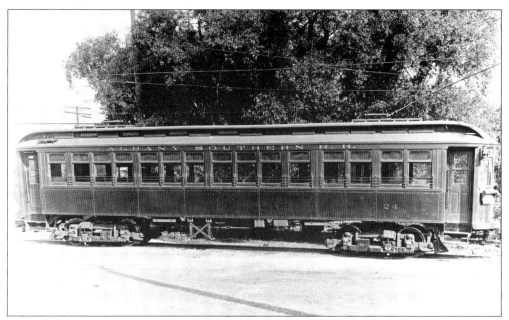

In 1903, the company name was changed to the Albany and Hudson Light and Power Company. Two years later, the name Albany Hudson Fastline was created to emphasize the quick time to get from Albany to Hudson. Only four years later, a new name was given, as seen on the side of No. 24, the Albany Southern Railroad. This name the company would hold on to the longest and is probably the name that it is remembered by today. (Frank Dodge collection.)

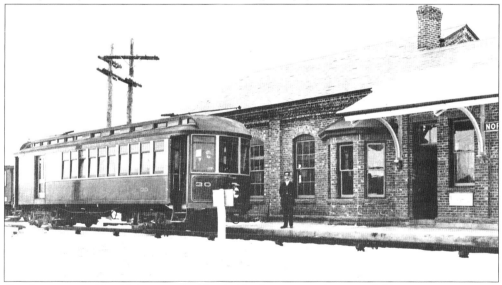

Combination car No. 30 (seen at the North Chatham station) was available to carry passengers and by using the rear side door carried less-than-carload freight. Several connections with freight railroads made the Albany Southern a legitimate freight carrier. Connections with the New York Central Railroad were made at Rensselaer and with the Boston and Albany Railroad at Niverville. Connection to steam lines was also available at Albany and Hudson. Milk trains were also run across the line with the New York Central Railroad continuing to New York City. (Smith/Bradford collection.)

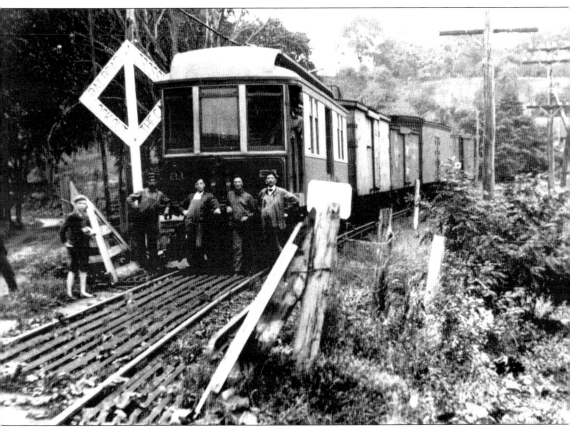

No. 21 was an express-box-motor used to pull freight like the one seen above at the Rossman's crossing. Rossman's was located south of Stuyvesant Falls. The Albany Southern Railroad ran daily (except Sundays and holidays) freight service leaving Albany at 5:30 and 11:30 a.m. and Hudson at 7:45 a.m. and 2:15 p.m. The Albany terminal was at the Electric Express station on State Street. The Electric Express was an early version of Fed-Ex and UPS and made runs over the Schenectady Railway and UTC. (Smith/Bradford collection.)

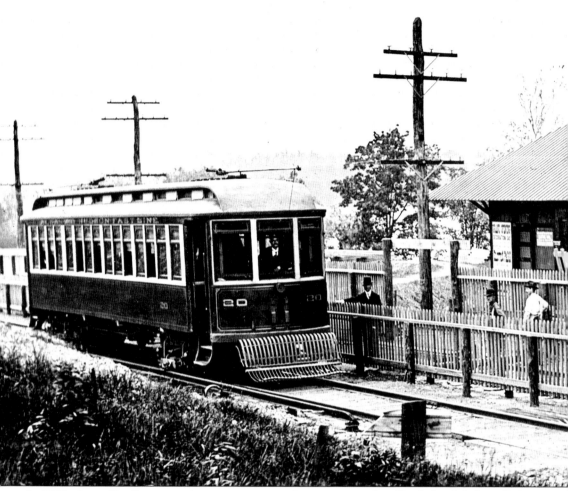

In 1900, the trolley line opened an amusement and recreation park at Kinderhook Lake called Electric Park. It was located right between the cities of Hudson and Albany, and travelers made their way from Troy and Albany and south from Catskill and Hudson to visit the park. Entrance to the park was included in the price of the trolley fare. Local travelers could pay 10¢ to enter and enjoy two Ferris wheels, one inside and one out, a roller coaster, a carousel, Chute-the-Chutes, a penny arcade, and a miniature railway. No. 20 arrives at the park above with a full load of passengers from the Albany, Watervliet, and Cohoes area. Advertising for the park appeared in 25 newspapers in Rensselaer, Troy, Cohoes, Watervliet, Hudson, Coxsackie, and Catskill. (Frank Dodge collection.)

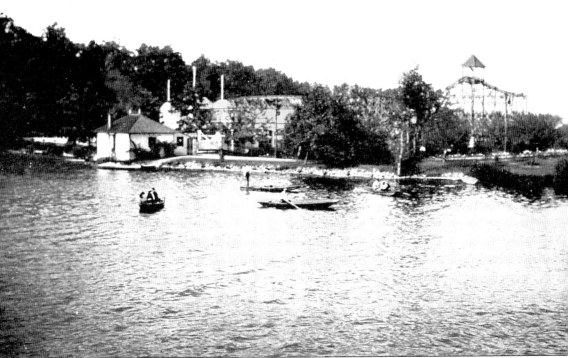

Amusement rides like the ones above were not the only attraction at Electric Park. A beach for swimming and fishing, a bowling alley, a dancing pavilion, and two open-air theaters with entertainment from New York City were also a big draw. The park shut down in 1917 due to World War I and never regained its popularity when troops returned. Automobiles made it convenient to travel to parks not serviced by trolley cars. (Author's collection.)

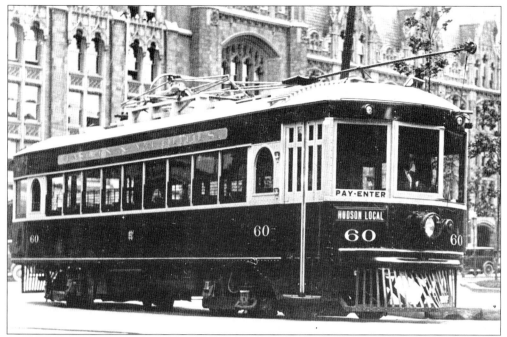

In the early 1920s, dwindling traffic forced the Albany Southern Railroad to find ways to save money. Two lightweight, steel cars were purchased from Cincinnati, Nos. 60 and 62. Not only did these cars save on power but they also could be operated by one person and not the typical two-man crew. No. 60 is seen here at the Delaware and Hudson office building in downtown Albany. For the last time, one more name change would make the company Eastern New York Utilities, a forerunner to Niagara Mohawk Power Corporation. The new name is on the side of No. 60. (Smith/Bradford collection.)

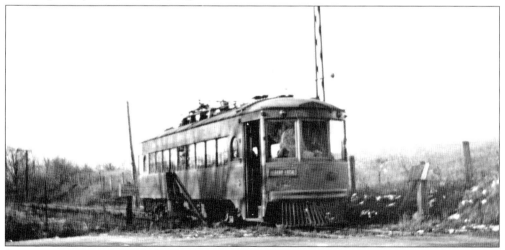

Sister car No. 62 is seen at a farm crossing on its way to Hudson. Nos. 60 and 62 were eventually sold to the Fonda Johnstown and Gloversville Electric Railroad after the line's abandonment and then went to Portland Traction in Oregon to provide a few more years of service. In December 1929, poor revenue led to the abandonment of the former Albany Southern trolley line. The final trip was made by No. 21 on Christmas Eve when all remaining cars were brought to Rensselaer and stations were boarded up along the way. (Frank Dodge collection.)

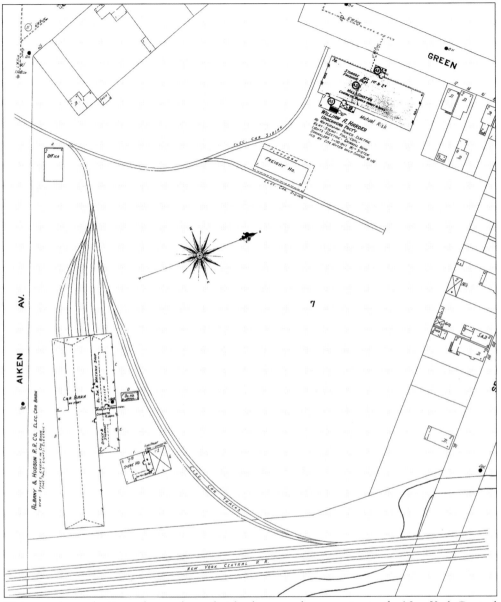

This map shows the Rensselaer carbarn, freight depot, and connection to the New York Central Railroad main line. (Author's collection.)

Five

FONDA JOHNSTOWN AND GLOVERSVILLE RAILROAD

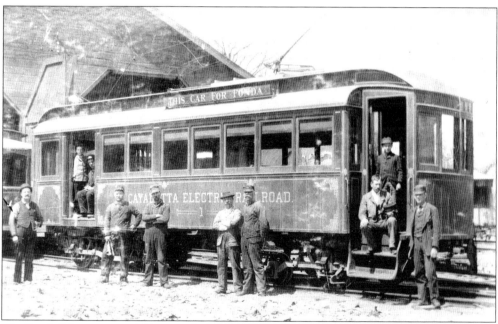

The Fonda Johnstown and Gloversville (FJ&G) Electric started with the Johnstown, Gloversville and Kingsboro Horse Railroad (JG&K) in 1873. Another line, the Cayadutta Electric Railroad, started up in the 1890s with a route from Fonda to Johnstown and then a connection to Gloversville. It was a direct competitor of the JG&K. The JG&K was absorbed into the Cayadutta, and then the Cayadutta merged with the FJ&G to form the FJ&G's electric division. In 1873, a horse railroad was constructed in Amsterdam to become the Amsterdam Street Railroad. An extension to Rockton created the Amsterdam and Rockton Street Railroad. Controlling interest was purchased by the FJ&G, thus extending the FJ&G Electric from Gloversville to Amsterdam. (Author's collection.)

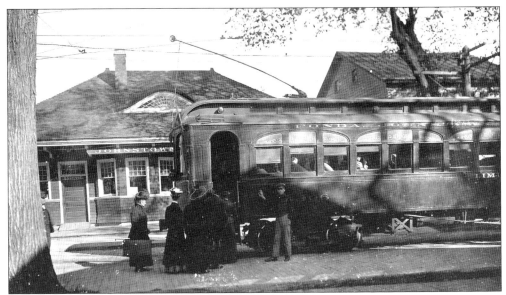

Not long after the FJ&G connected to Amsterdam, sights were set on a bigger connection—Schenectady. Regular service from Fulton County to Schenectady began in 1903. A large powerhouse was constructed near Tribes Hills and needed to generate enough electricity to move cars across the Mohawk Valley. The FJ&G's trackage really only reached as far as Scotia-Glenville, but rights were given by the Schenectady Railway Company to use its Washington Avenue bridge and gain access to downtown via State Street. To make the trip to Schenectady in comfort and style, the FJ&G purchased several luxury coaches from St. Louis and numbered them 101 through 107. Above, car No. 106 sits in front of the Johnstown trolley station with passengers boarding for Schenectady. (Nestle collection.)

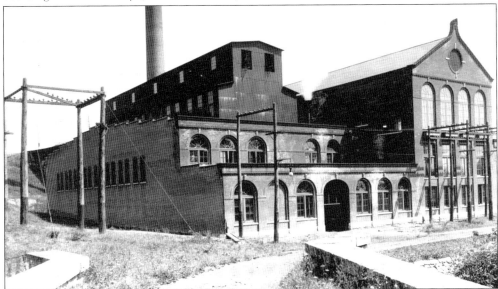

The powerhouse in Tribes Hills had a smokestack that was 170 feet high, one of the highest in the United States for 1903. It provided current for the three FJ&G substations, one located in Glenville, one in Amsterdam at the former street railroad powerhouse, and the last in Johnstown, built in the Cayadutta Electric's former substation. (Nestle collection.)

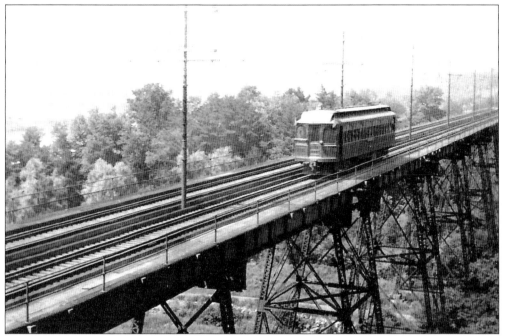

This steel viaduct was located right beside the powerhouse in Tribes Hills, halfway between Johnstown and Amsterdam. It was 584 feet long and rose 72 feet above the ravine below. This bridge was dismantled right before World War II, and its steel was reused in the war effort. (Author's collection.)

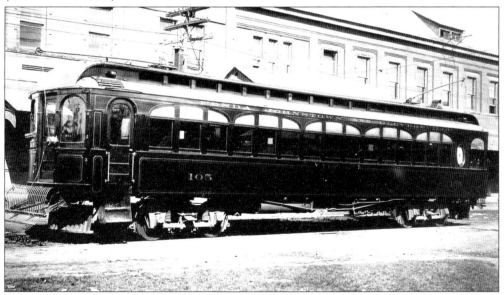

Car No. 105 sits alongside the Victorian Gloversville passenger station. These cars were some of the heaviest trolleys used in the Capital District. The FJ&G had dreams of connecting Gloversville with Albany by using the Schenectady Railway trackage between Albany and Schenectady and then the UTC to the capital. The UTC deemed the cars too heavy and would not allow them access. FJ&G interurbans did make special runs on the Schenectady Railway by using the Ballston line to visit Saratoga Springs. (Author's collection.)

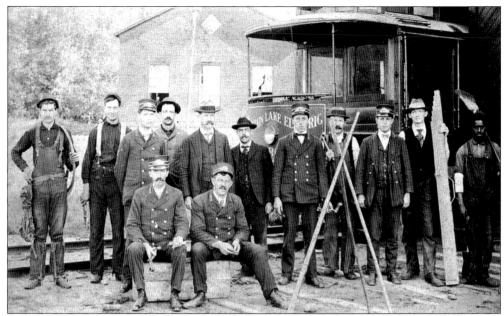

Adding to the crowded picture of trolley lines in Fulton County, the Mountain Lake Electric Railroad was built in 1901 to connect Gloversville with a Bleeker Mountain resort for a distance of 4.35 miles. The road took a steep route up the mountain with several S curves that were an accident waiting to happen. On July 4, 1902, two carloads of passengers made their way down the mountain to Gloversville. (Fulton County Museum.)

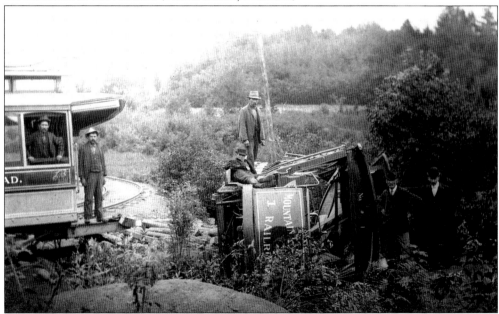

Car No. 5 lost control and rammed into the back of car No. 1, sending it on its side and car No. 5 on top of it. In the aftermath, 13 passengers died and many more were seriously injured. The accident and subsequent lawsuits bankrupted the line, and the FJ&G bought it in 1904 and ran it as the Adirondack Lakes Traction Company. Safety improvements were made, but the line eventually closed in 1917. (Fulton County Museum.)

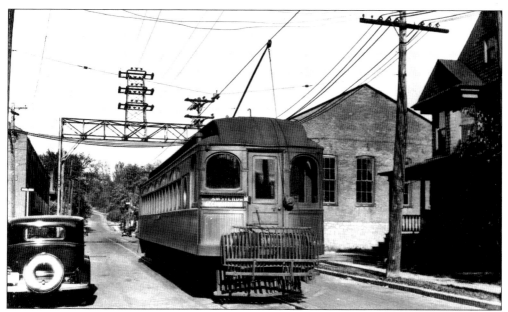

An FJ&G interurban is seen traveling down Henrietta Boulevard in Amsterdam. The building to the right was the carbarn for the Amsterdam Street Railroad and later the FJ&G's electric division. The electrical towers behind the trolley car connected to the Amsterdam substation, which provided power to the cars around the lines of the city and up to the extension to Hagaman and Harrowers. (Len Garver collection.)

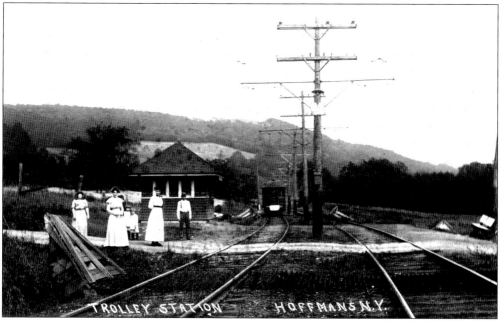

Ladies in their Sunday finest wait for a car on the Schenectady line at the Hoffmans trolley stop. These small shanties were located all along the route between Sulphur Springs Junction and Schenectady. One remains as a school bus stop on Old Post Road above Tribes Hills. (Jerry Snyder collection.)

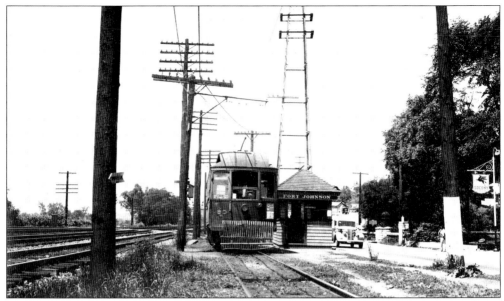

No. 60 makes a stop at the Fort Johnson trolley stop on its way to Amsterdam. Three modes of transportation are in action in this photograph. The grand four-track main line of the New York Central Railroad's Chicago line sits to the left, the Mohawk Turnpike (New York State Route 5) is on the right, and the FJ&G electric division is in the center. Out of view is the New York State Barge Canal (Erie Canal). (Fulton County Historical Society.)

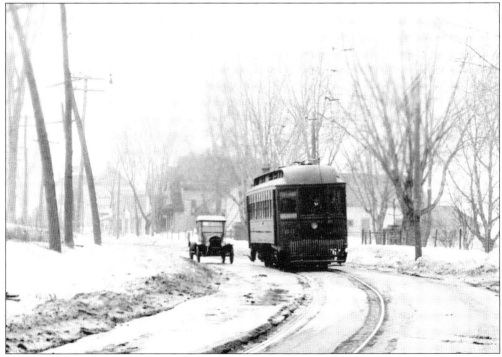

Once again No. 60 is in action. This time it is making the curve between Gloversville and Johnstown on its way back to the "Glove City" via Main Street. To the right is Ferndale Cemetery. (Nestle collection.)

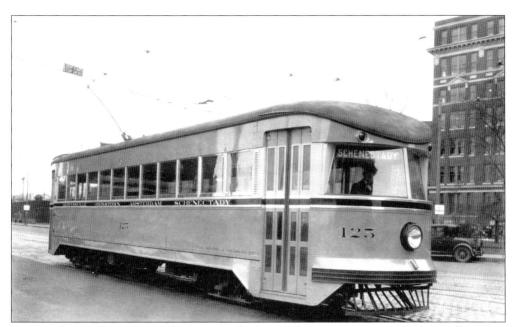

In 1931, the FJ&G, coping with mounting losses, tried to get more people in its trolleys. Five aluminum streamliners were purchased from the J. G. Brill Company of Philadelphia for $20,000 a piece and placed into service on the Schenectady line. New incentives, including fares of 1¢ a mile, were put into effect, but the tide of the automobile was too strong. (Malcolm Horton collection.)

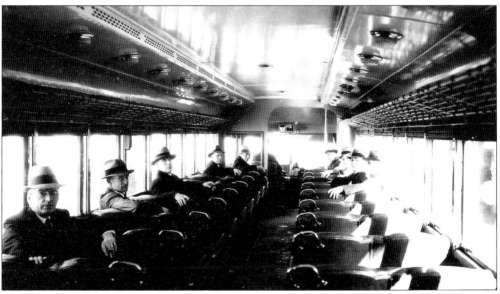

Making a promotional run, the FJ&G's board of directors enjoys the comfort of the new streamline cars. A trip was made between Gloversville and Schenectady to show off the new company equipment. (Malcolm Horton collection.)

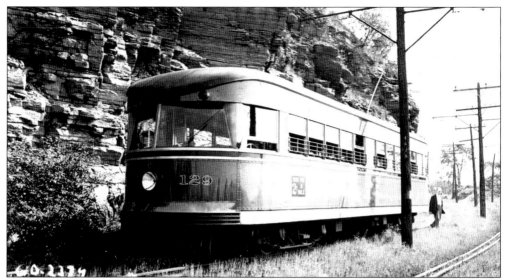

The popularity of the Brill Bullets may not have saved the FJ&G Electric, but they were pretty popular with the railfan crowd. Several fan trips were run like the one above. No. 129 makes a stop at the Cranesville Cut between Amsterdam and Schenectady. The car was stopped, and railfans were able to exit the car and take photographs of it with the view of the rock cut behind it. This view can be enjoyed today as one makes a trip eastbound on New York State Route 5. (Author's collection.)

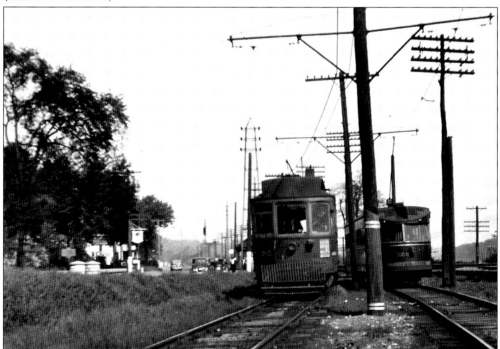

Old and new meet at Fort Johnson. This photograph was taken in 1937 by a teenage railroad fan by the name of Robert G. Lewis. Lewis and his brother rode a train from Philadelphia to New York City and then to Schenectady so they could snap pictures of railroads in action. Lewis went on to be an editor for *Railway Age* magazine in 1947. (Robert G. Lewis collection.)

By 1929, the FJ&G started substituting buses on its trolley lines. After a deal was struck with the union and FJ&G management, all trolley motormen were given the new bus routes that ran over their former trolley routes. (Nestle collection.)

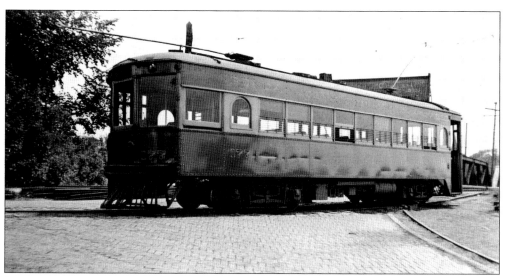

FJ&G No. 177 waits at the foot of the Washington Avenue bridge in Scotia just before abandonment of all trolley lines. The bridge had been condemned at this time, and the Brill Bullets were not able to turn around, so cars like No. 176 and No. 177 and the old St. Louis cars were pressed into service. On the night of June 28, 1938, No. 176 made the last trip from Gloversville to Schenectady and back. Buses took over on the whole line, and electric service ended. (Nestle collection.)

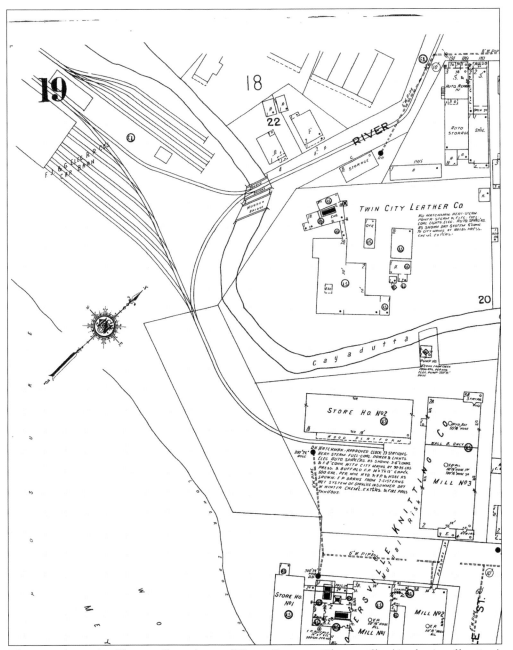

This map shows the Gloversville carbarn off River Street in Gloversville. (Author's collection.)

Six

BALLSTON TERMINAL RAILROAD

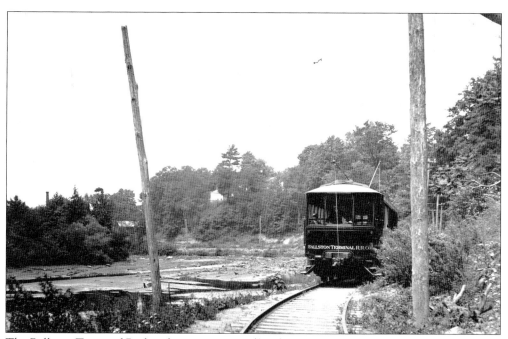

The Ballston Terminal Railroad was a passenger/freight road that ran from the village of Ballston Spa to Middle Grove in the town of Greenfield. It was created in 1899, built for a sum of half a million dollars, and was nine miles in length. It served a number of mills along its route, and it made its freight interchange with the Delaware and Hudson Railroad at Ballston Spa. (Frank Dodge collection.)

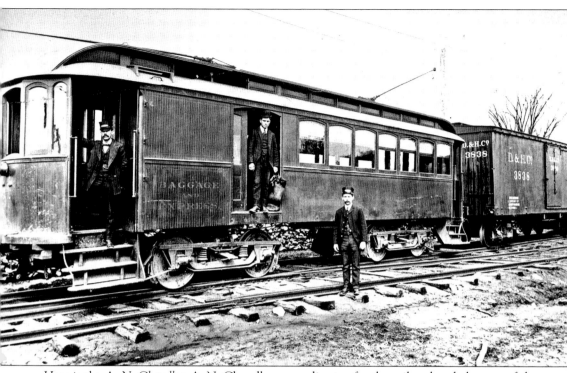

Here is the *A. N. Chandler*. A. N. Chandler was a director for the railroad and also one of the original investors. The *A. N. Chandler* was one of the first cars purchased by the company and probably the last car to run on the line. No. 4 was an open car used for passenger runs, and the second-most-popular traction engine on the line was No. 3, also known as the *George West*. George West was the inventor of the paper, square-bottom bag, created after cotton became too important following the Civil War. The West Mill Complex was built right along Kaydeross Creek and was serviced by the trolley line. In the photograph above, the *A. N. Chandler* gets ready to interchange cars with the Delaware and Hudson Railroad at Ballston Spa. The Ballston Terminal Railroad picked up its cars from the Delaware and Hudson Ballston yard on a track with overhead wire with enough distance to keep the car powered. This interchange was located right where present-day Route 50 climbs the hill out of the village of Ballston. (Smith/Bradford collection.)

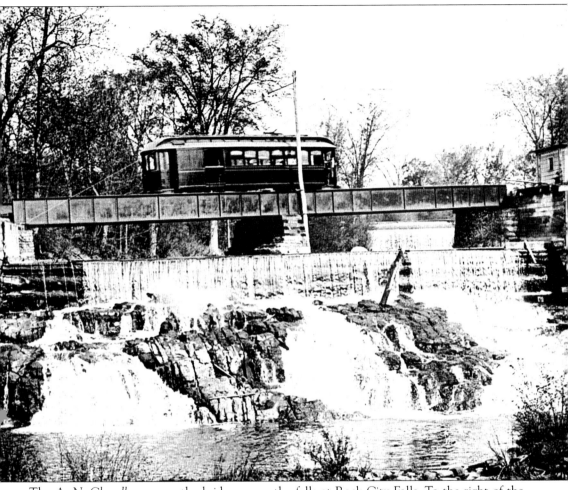

The *A. N. Chandler* crosses the bridge across the falls at Rock City Falls. To the right of the bridge is the Cotrell Paper Company, oddly enough one of the few businesses located close to the line that did not utilize it for transportation of its goods. (Len Garver collection.)

Ballston Terminal A. N. Chandler is seen with a mixed train (both freight and passengers being carried) on the Galway Road in Rock City Falls. Currently this is New York State Route 29. In the background is the steeple for St. Paul's Catholic Church, which continues operation today. (Smith/Bradford collection.)

Taken at the same time as the photograph above, the A. N. Chandler (sans freight cars) makes its way up the line to Middle Grove. The bridge to the right is carrying the Galway Road over Kaydeross Creek. The Ballston Terminal Railroad paralleled the Middle Grove Road all the way to the end of the line. (Smith/Bradford collection.)

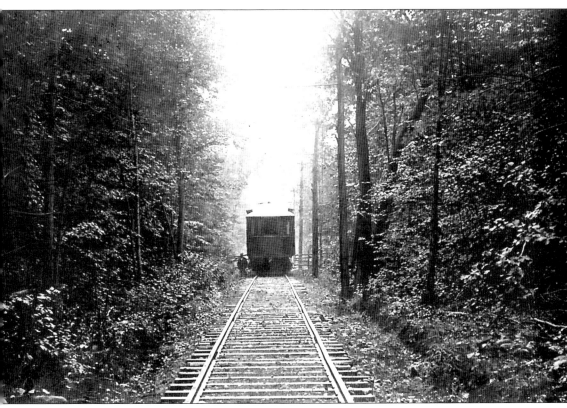

A trolley car is seen in the Pioneer Woods, just north of the village of Ballston Spa. After the initial construction of the Ballston Terminal, this was the official end of the line. Soon after, the extension to Rock City Falls and Middle Grove would be completed. This photograph appeared in a brochure for the company titled *For an Idle Hour* describing the time to travel the line and the picturesque views encountered along the way. In 1904, the Ballston Terminal Railroad was sold at auction. A. N. Chandler, one of the original investors, bid $150,000 but was outbid by a group from Philadelphia for $175,000. The new investors had hoped to expand the operation westward, with dreams of connecting to the FJ&G in Amsterdam. The name Eastern New York Railway was chosen, perhaps in hope of creating a regional system, but expansion never materialized. (Author's collection.)

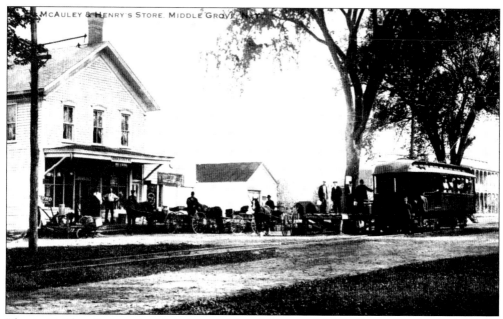

The *A. N. Chandler* is at the McAuley and Henry's Store in Middle Grove. The local post office was also located at the store. In the photograph, horses and wagons drop off their goods to be loaded on the trolley car via the platform next to the car. (Author's collection.)

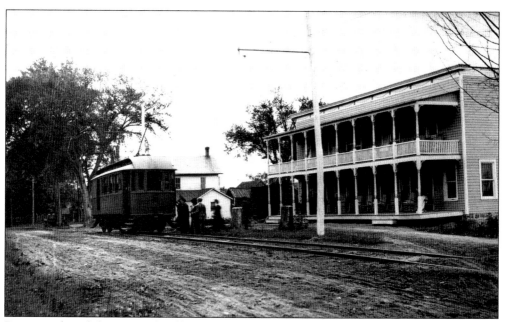

Passengers board the *A. N. Chandler* at the hotel in Middle Grove for their trip back to Ballston Spa. (Smith/Bradford collection.)

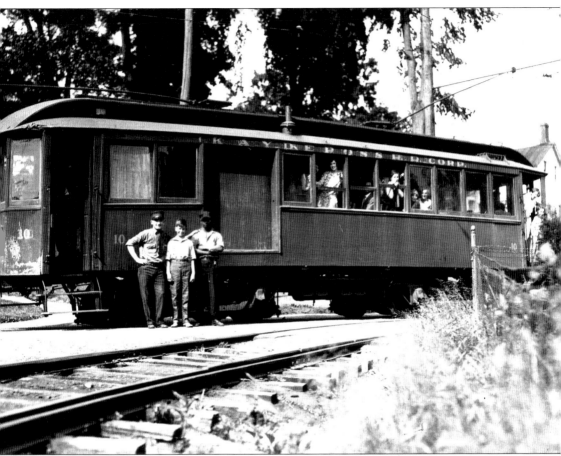

With the end of the railroad a short time away, the crew of the *A. N. Chandler* poses with schoolchildren from Ballston Spa who affectionately dubbed the railroad the PP&J, an abbreviation for "Push Pull and Jerk." The name was shared by locals and schoolchildren to describe the trip down from Middle Grove. The location of this photograph is the Milton Avenue wye in Ballston Spa. The entire Kaydeross Railroad operation was abandoned on June 7, 1929, ending 30 years of small-town transportation history. (Smith/Bradford collection.)

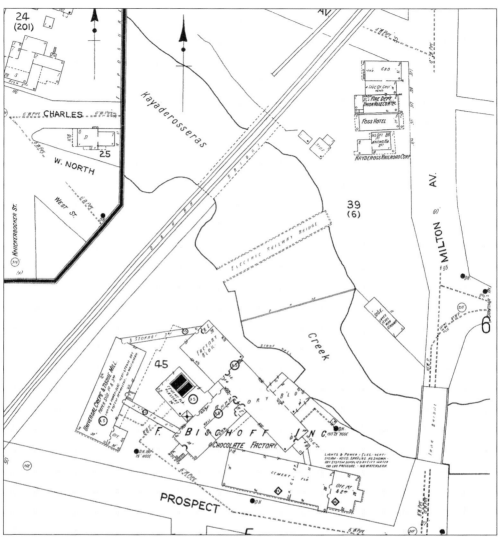

This 1924 map shows the mill at Prospect Street, bridges carrying the Delaware and Hudson and Ballston Terminal Railroads over Kaydeross Creek, and the depot for the Kaydeross Railroad Corporation. (Author's collection.)

Seven

TROY AND NEW ENGLAND RAILWAY

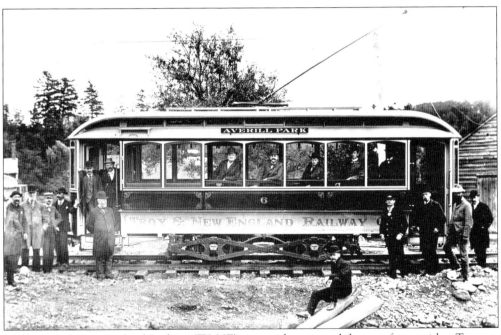

The Troy and New England Railway (T&NE) was an electric road that ran from neither Troy nor New England. Actually, it started in Albia and ran out to Averill Park. Along the way, it passed through Wynantskill, Snyder's Corners, Postenkill, and West Sand Lake. In the photograph above, T&NE No. 6 poses with the line's financiers in Averill Park on September 30, 1895. It is also the same car to run on the line on March 31, 1925. (Smith/Bradford collection.)

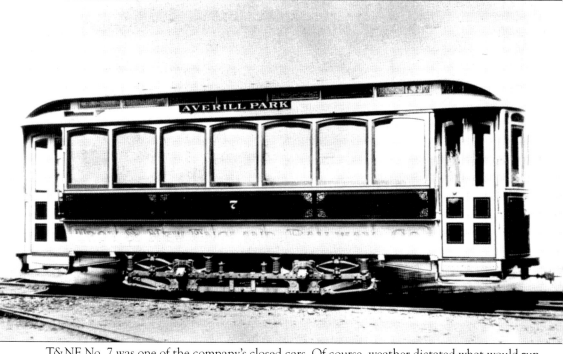

T&NE No. 7 was one of the company's closed cars. Of course, weather dictated what would run on the line: closed cars for winter and open for summer. One popular summer destination was the picnic grove at Brookside Park in West Sand Lake. Commuters did utilize the line, but the bulk of travel dealt with summertime recreation. (Smith/Bradford collection.)

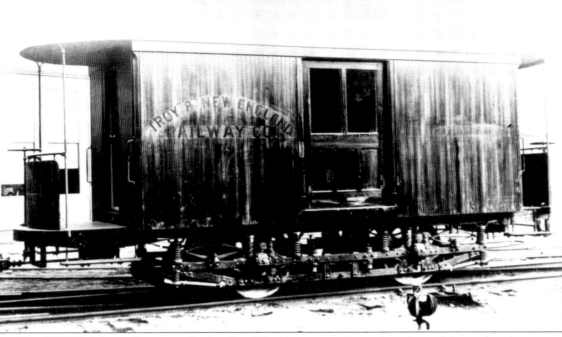

The T&NE did not have standard railroad freight cars at inception, instead it employed four-wheel trailer cars like the one above. Packages and express shipments were carried on the line, but it was not out of the question for the line to haul coal and shoddy to the mills of West Sand Lake and Averill Park. (Smith/Bradford collection.)

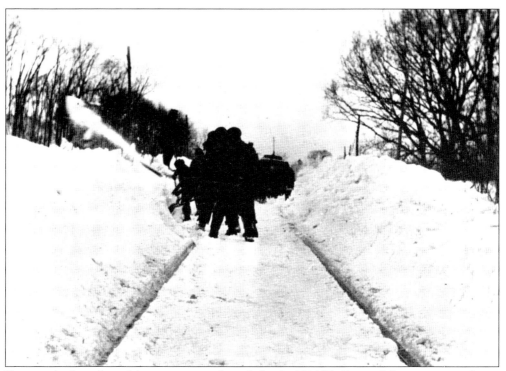

Keeping the line cleared for winter was a big job for the T&NE. George Johnson was in charge of cleaning up the line. With the help of men from the UTC and a rotary snowplow, the job was taken care of. (Smith/Bradford collection.)

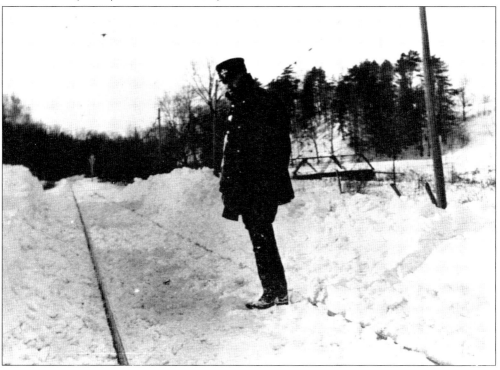

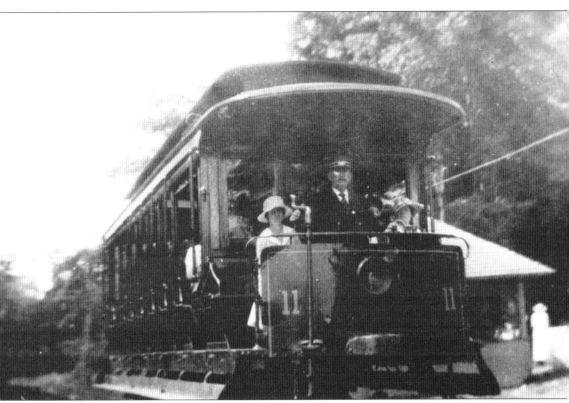

The T&NE was known to the residents of Troy as the "Huckleberry Line," some say as a reference to the residents of Troy who used the trolley to pick berries in the countryside. Getting from the cars of the city of Troy to cars of the T&NE required some walking. One had to take a Troy City car on the No. 3 Albia line from downtown Troy and then walk a block to reach the T&NE's terminal. Old timetables say that the T&NE ran two cars an hour in the summer and scaled back to one car per hour in the summer. (Smith/Bradford collection.)

Here is the last car to run on the T&NE. By this time, the T&NE was property of the UTC. The UTC retained the T&NE equipment and ran it as the UTC's Albia line. No. 6, which was the first car to run on the line, was also the same car but now with UTC marks. The last run took place on March 31, 1925, and Joseph Tarpey was the motorman in charge. The line had lost a considerable amount of passengers to a new bus line in the area named the KLWM. It ran

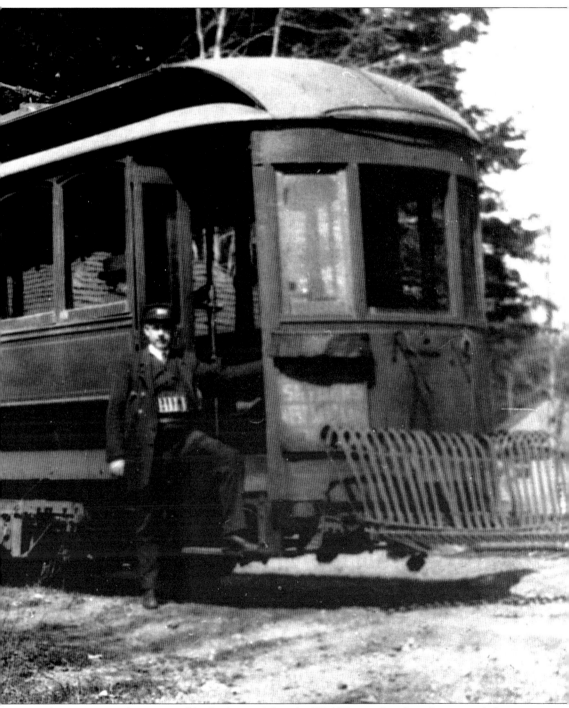

over the same route but on a public highway. After the T&NE was abandoned, it extended its line to Glass Lake. It also was taken over by the UTC and ran for a short time after the Capital District Transportation Company (CDTA) took over bus transportation in the Capital District. (Smith/Bradford Collection.)

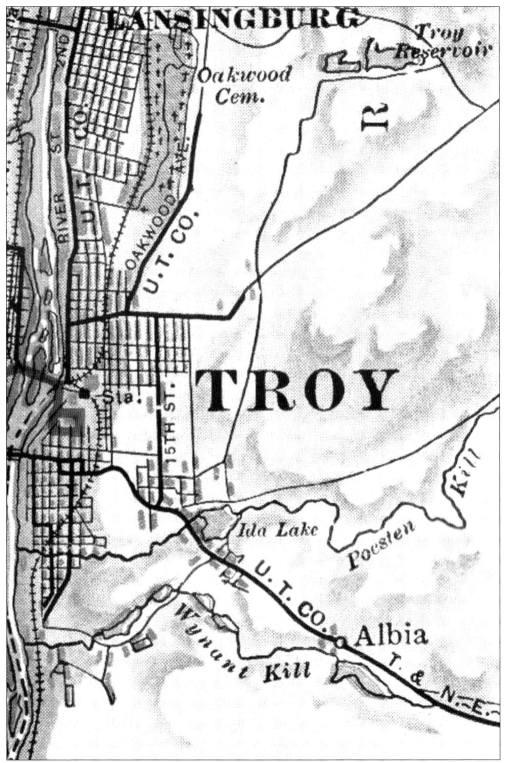

Here is a map showing the UTC and its connection to the T&NE at Albia. (Author's collection.)

BIBLIOGRAPHY

Gordon, William Reed. *Third Rails, Pantographs & Trolley Poles: The Story of The Albany & Hudson Railway & Power Company, 1899-1903, The Albany & Hudson Railroad, 1903-1909, The Albany Southern Railroad, 1909-1924, The Eastern New York Utilities Corporation, 1924-1929, and Including The Hudson Street Railway, 1890-1927.* Self-published, 1973.

Mowers, Robert D. *Electric Cars in the Electric City.* Wheaton, IL: Traction Orange Company, 1965.

Nestle, David F. *Rails along the Kaydeross: A History of the Little Railroad with Big Ideas.* Greenwich, NY: Self-published, 1999.

———. *Saratoga Through Car—A History of the Hudson Valley Railway.* Greenwich, NY: Self-published, 1967.

Nestle, David F., and William Reed Gordon. *Steam and Trolley Days on the Fonda, Johnstown and Gloversville Railroad.* Milford, NY: Fonda, Johnstown and Gloversville Railroad Company, 1958.

Across America, People are Discovering Something Wonderful. Their Heritage.

Arcadia Publishing is the leading local history publisher in the United States. With more than 3,000 titles in print and hundreds of new titles released every year, Arcadia has extensive specialized experience chronicling the history of communities and celebrating America's hidden stories, bringing to life the people, places, and events from the past. To discover the history of other communities across the nation, please visit:

www.arcadiapublishing.com

Customized search tools allow you to find regional history books about the town where you grew up, the cities where your friends and family live, the town where your parents met, or even that retirement spot you've been dreaming about.